W9-AAS-765

EGYPT

Stones of Light

EGYPT
STONES OF LIGHT

HERVÉ CHAMPOLLION

TEXT BY DIANE SAROFIM HARLÉ

TRANSLATED FROM THE FRENCH BY TOULA BALLAS

HARRY N. ABRAMS, INC., PUBLISHERS

Introduction

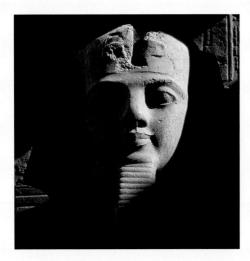

In the times of the pharoahs, the Egyptian's view of the world was fashioned by the blazing light of the sun. Bordered by high cliffs, the plains of the Nile River Valley lend themselves easily to this play of light and shadow. The daystar disperses a full range of colors on the objects it illuminates, from the phosphorescent red of sunrise to the harsh white of noon. At sunset, it bathes the sky of the western horizon in its fiery and dramatic light. The sun gives light and also warmth; at its zenith, it seems to make the statues and outdoor reliefs shimmer as if they were animated by an interior force.

Temples stand like fortresses of the gods. Built in the image of the earth, with their irregular surfaces, the buildings translate the fertile soil of Egypt into architecture. The columns recall the lush vegetation of the banks of the Nile; rising toward the sky-blue ceiling, where the sacred vultures fly, they evoke the celestial vault. With their images of gods, kings, and the faithful, the decorated statues and reliefs live in and around the sacred site that the temple defines. Even the smallest detail in this petrified world is a marvel of technique, harmony, and sensitivity.

The god Ra and sun disk Aton, deification of the sun itself, to name only a couple of deities, play a fundamental role in the works created by the Egyptians. The radiance of these all-powerful divinities glides in. It insinuates itself, caressing not only the statues, the "living beings," but also the reliefs decorating the exterior sanctuary walls. It lightens the heaviness of the pylons and illuminates the tops of the obelisks. The sun flattens out the reliefs but, twice a day, a bright shaft of light lengthens the shadows and accentuates the carved hollows and projections. Inside the hypostyle halls, rays filter down through the stone grills of the windows and animate the mural scenes. At its will sunlight travels over and reveals the contours of statues, highlighting different details according to the hour of the day.

Working only in daylight to make his photographs, Hervé Champollion entered this spiritual world and found the perfect ray of the sun. Thanks to his infinite patience, he has been able to capture monuments and statues on film. Most important, however, he has uncovered and revealed their smallest details, those that often remain undetectable to the eye. Image by image, he has built a visual museum that, far from being imaginary, pays homage to the artists of the pharoahs. He gladly shares his world with us.

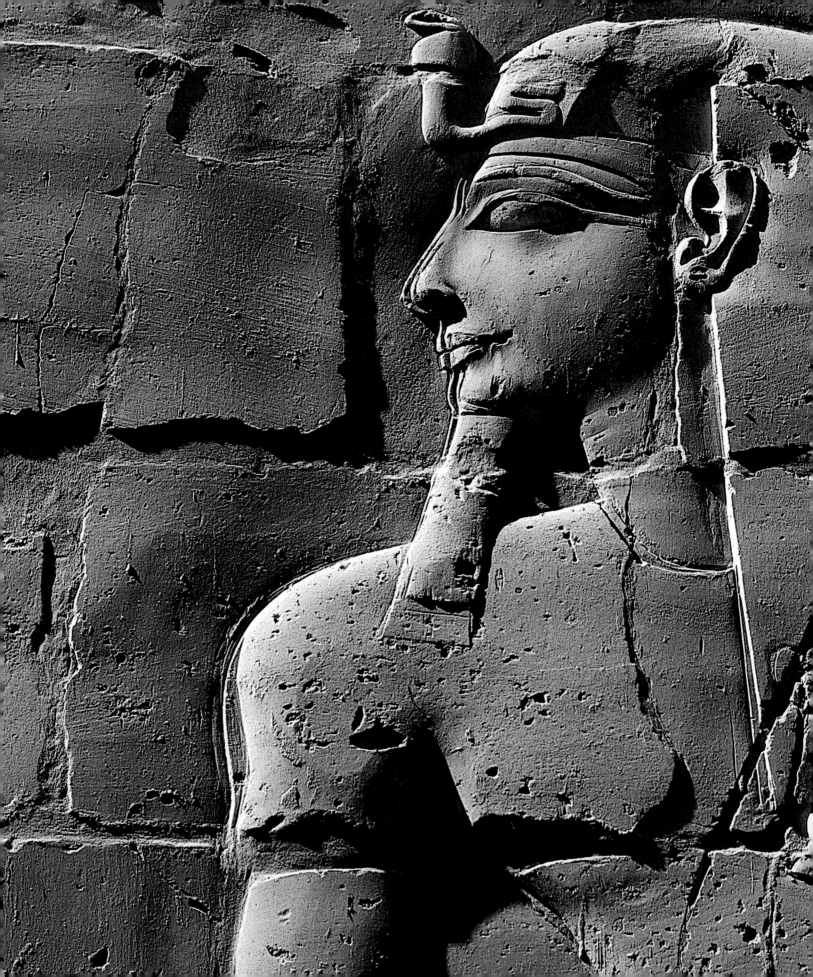

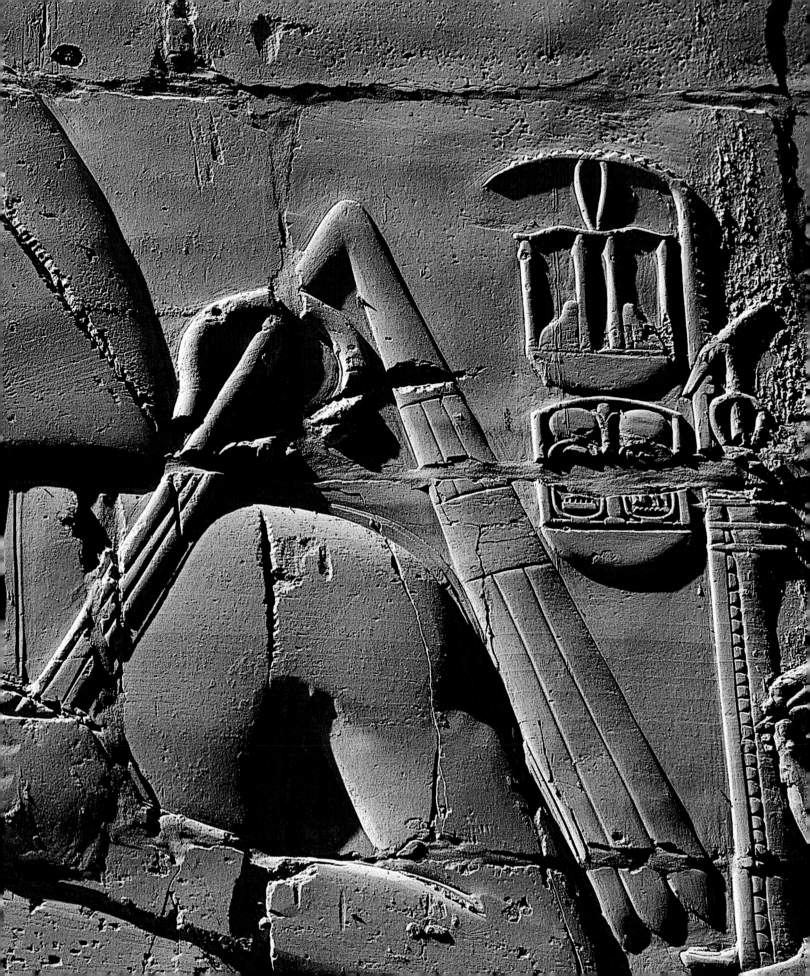

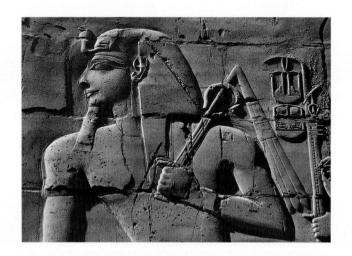

"So God created man in his own image." Many religions describe the creation in this same fashion, sometimes adding that He "made man out of clay."

In Egypt, this is one of the key birth myths since the Aswan god and master potter Khnum modeled the first human beings on a lathe. Like this god, the first Egyptian settlers gathered clay from the banks of the Nile and modeled it into crude figures of men and women called "fecondity figurines" to guarantee their afterlife. Then, to better preserve their fragile creations, they learned how to fire them. Still these objects remained too delicate; like human beings, they were unable to survive the wear and tear of time. Finally, the Egyptians discovered stone, and with it they created images of eternity.

But what face could man give God? In Egypt, the king was the son of gods, so why not make the gods in the image of pharaohs? Portraits of deities therefore bore the characteristics of the reigning sovereign and, this became a game of mirrors, one reflecting the other. These representations were placed in the temples—the palaces of the gods—and today we are still amazed by the stunning images of two people with identical faces, god and pharaoh, face to face.

How, then, do we differentiate the two? If we can use characteristics like clothing, beards, crowns, and scepters to distinguish god from king, we can make more specific identifications primarily by the painted or engraved names that accompany their images. The gods are most often associated with those places that the pharaoh partially took over during his reign.

As for other Egyptians, those who were neither gods nor pharaohs, what was their place in this land of the divine? Only a privileged few counted. Their statues stood here and there, and also received the veneration of the faithful. Some still carry traces of erosion where the countless hands of the devoted stroked away the stone. Just as most Christians in the Middle Ages were not permitted to cross the narthex of the church, ordinary Egyptians could not pass through the temple pylon. At best, as participants in the festival processions, they might have penetrated as far as the temple court.

Even during the New Kingdom, most Egyptian artists were anonymous. Still, we know the names of some famous sculptors: Men, Bak, and Thutmes at the time of Amenhotep III and his son, Akhenaton, as well as some artists from the village of Deir el-Medina. Looking at the carefully carved or drawn human figures, it is hard to believe that these sculptors worked only from memory. Some tomb decorations portray the artist and his model. We know too that aesthetic canons evolved from one era to the next, and artisans used squares to enlarge and trace their subjects. Artists, it is true, were supposed to meet certain hieratic standards, but they sometimes neglected the directives of authorities in order to emphasize specific elements they judged essential for their work. We must not forget that all these works, like Greek art, were stuccoed and painted; over time, due to the sun burning into the temples and various other kinds of deterioration, they have lost their original appearance.

The work of the pharaonic sculptor was animated by a great sensitivity, which corresponds perfectly to the role it was supposed to play through eternity: to be "alive." Egyptian statuary exists beyond the boundaries of time, and even today, we still regard it with enormous admiration.

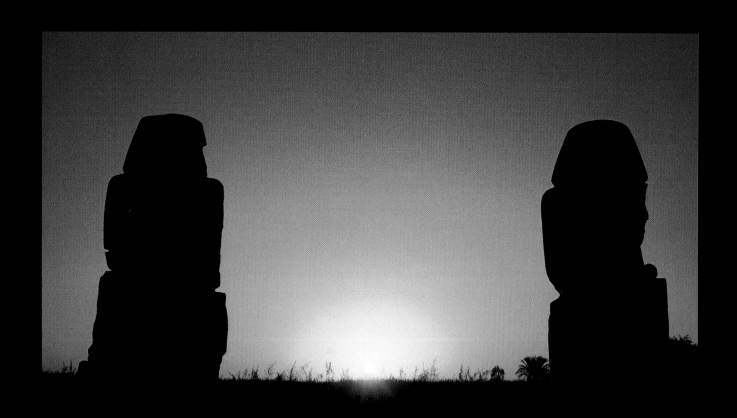

THE COLOSSI OF MEMNON. *Amenophium. Western Thebes.*
NILE GOD. *Amenophium. Western Thebes.* ▶

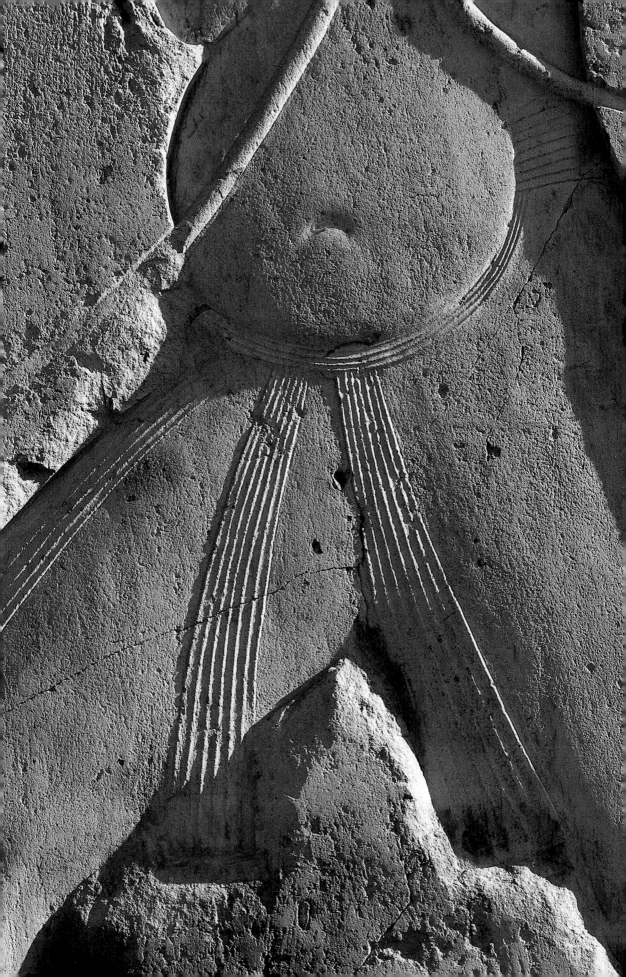

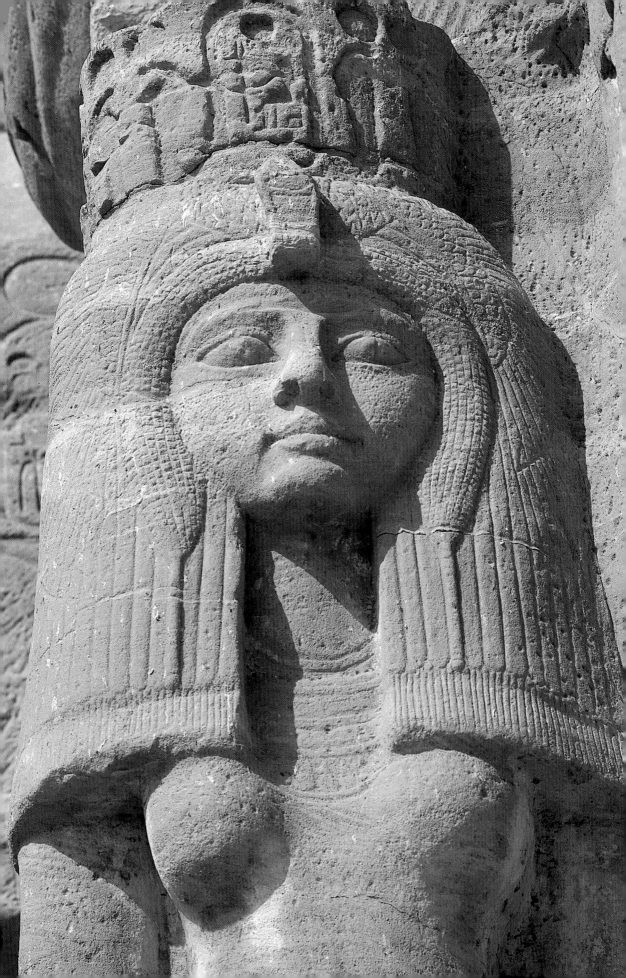

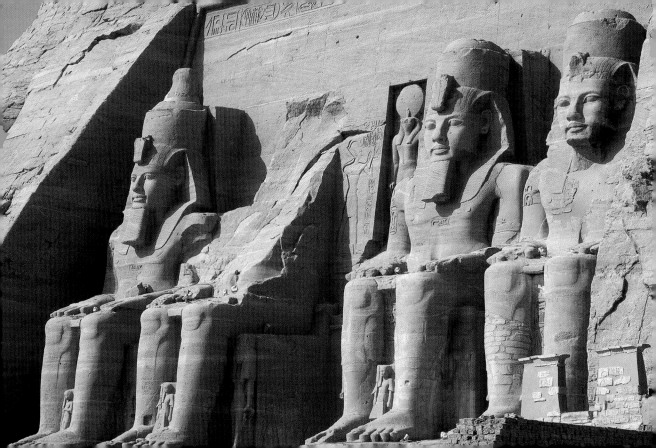

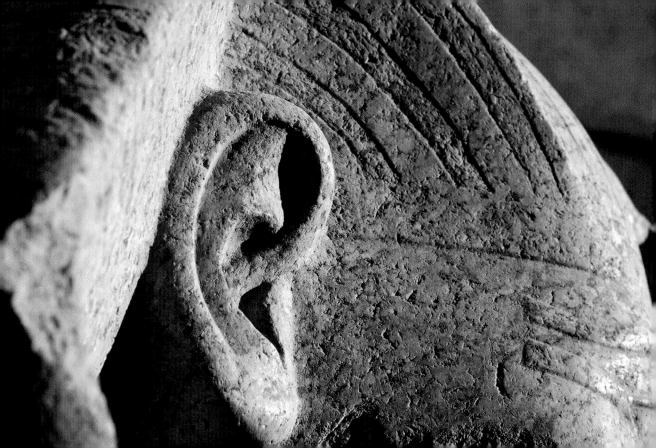

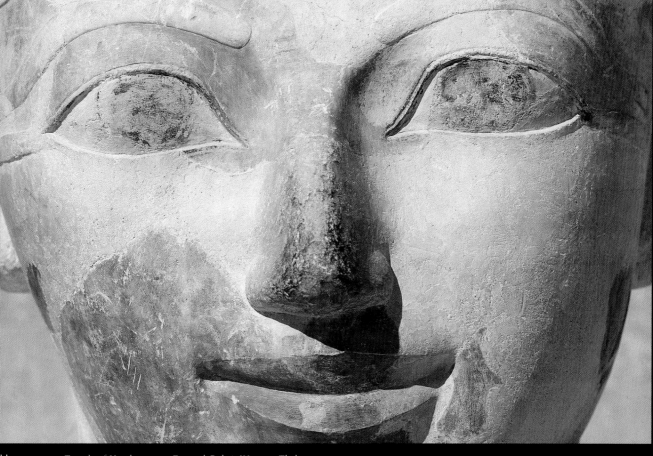

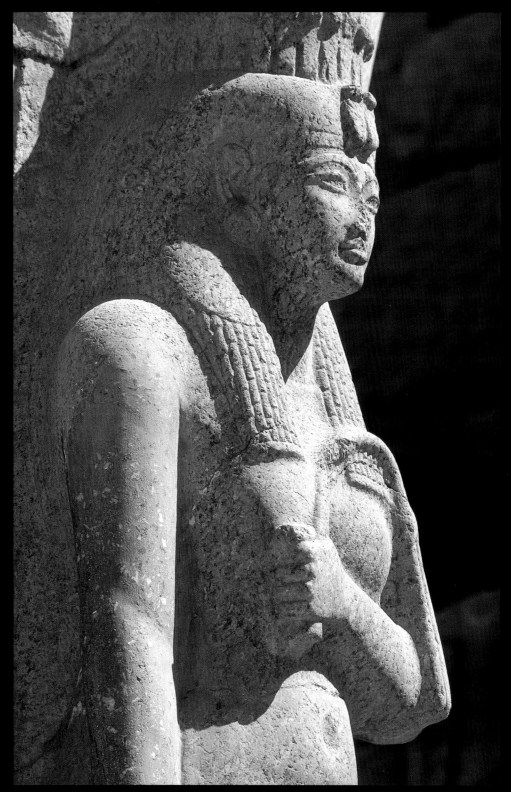

BENTANAT. *Temple of Amon Ra at Karnak. Eastern Thebes.*
RAMSES II. Speos *temple at Abu Simbel, Nubia.* ▶

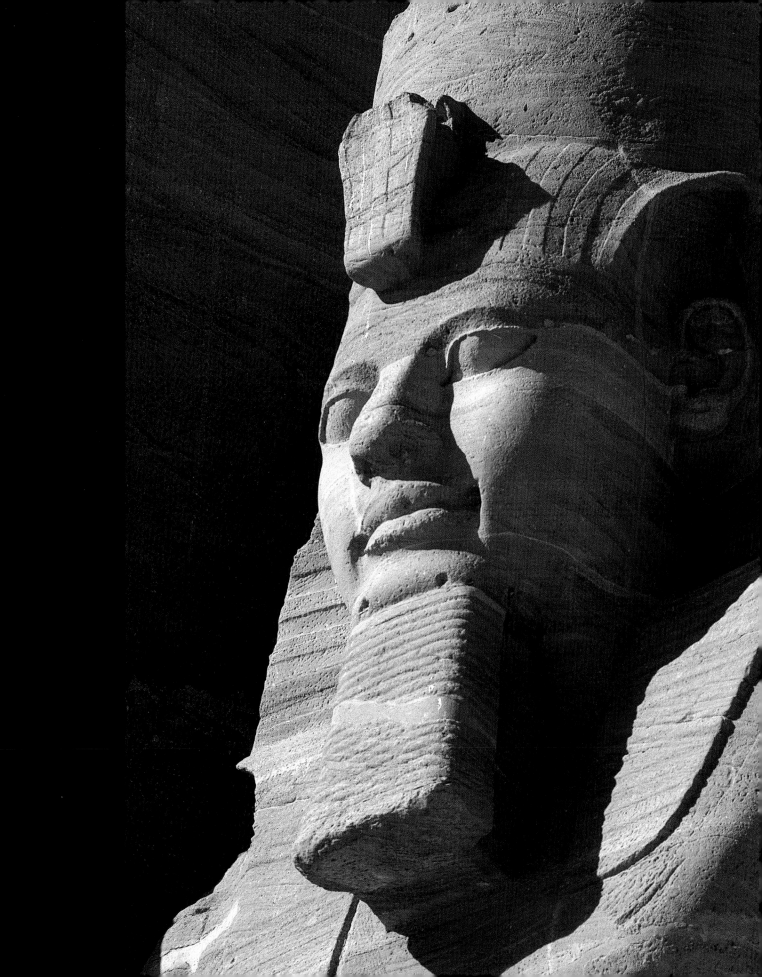

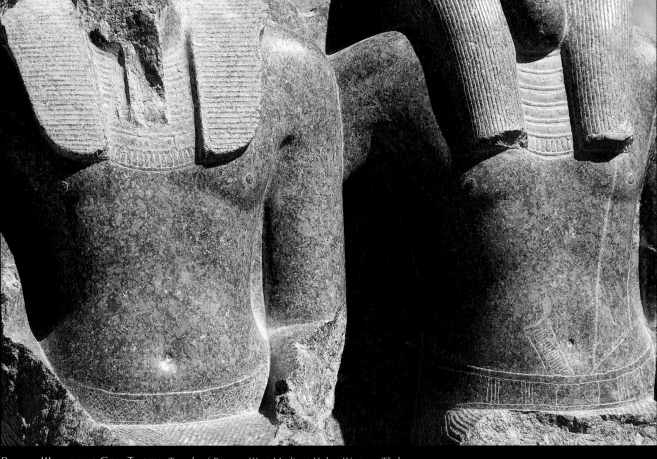

RAMSES III AND THE GOD THOTH. *Temple of Ramses III at Madinat Habu. Western Thebes.*

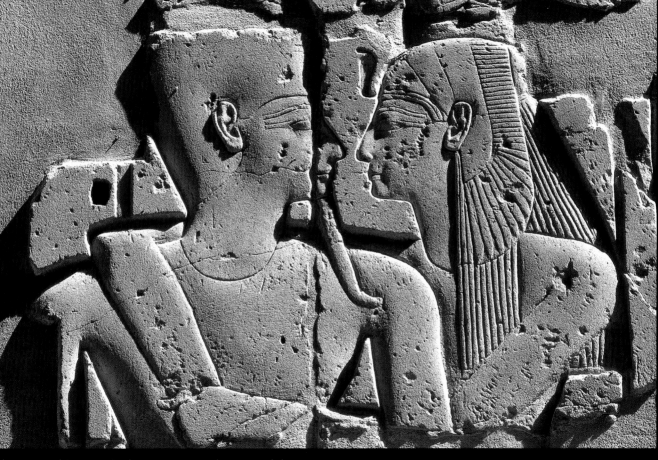

Amon and Mut. *Temple of Amon Ra at Karnak. Eastern Thebes.*

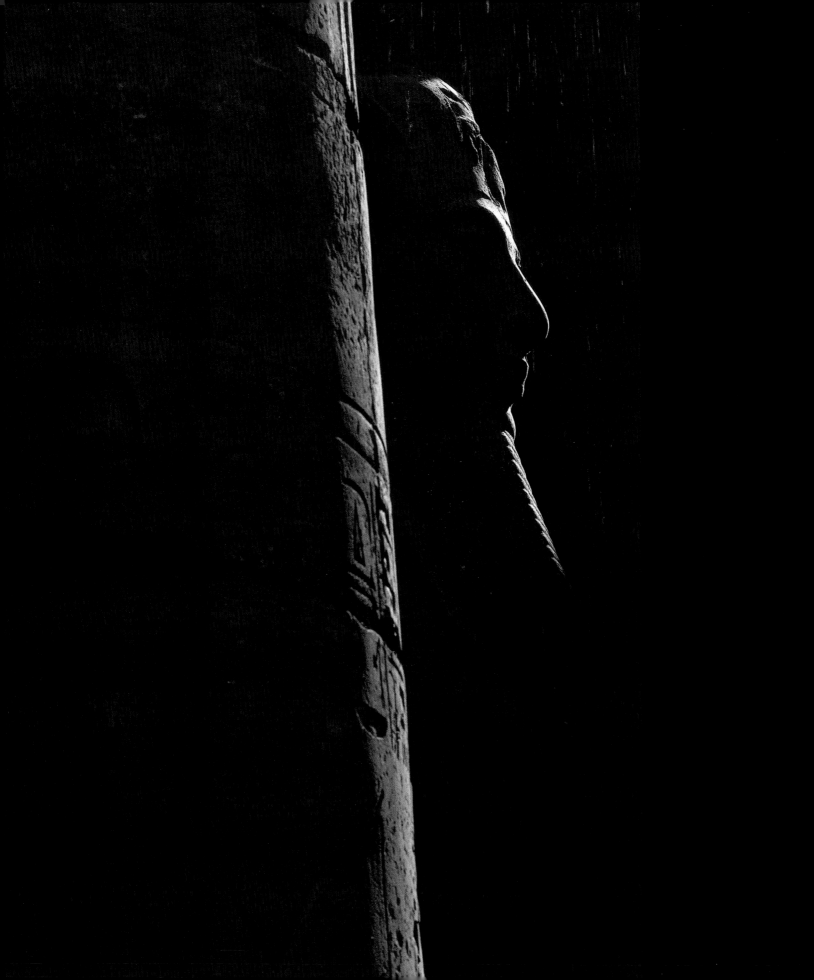

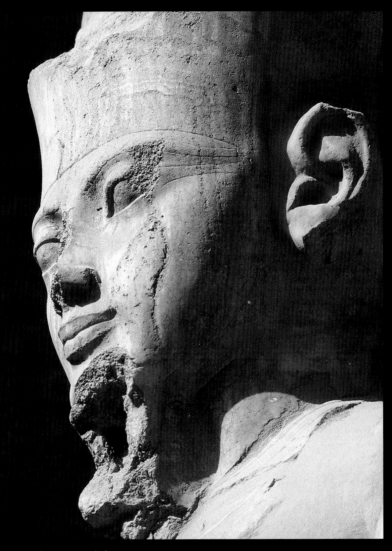

AMON. *Temple of Amon Ra at Karnak. Eastern Thebes.*

◄ RAMSES II. *Temple of Luxor. Eastern Thebes.*

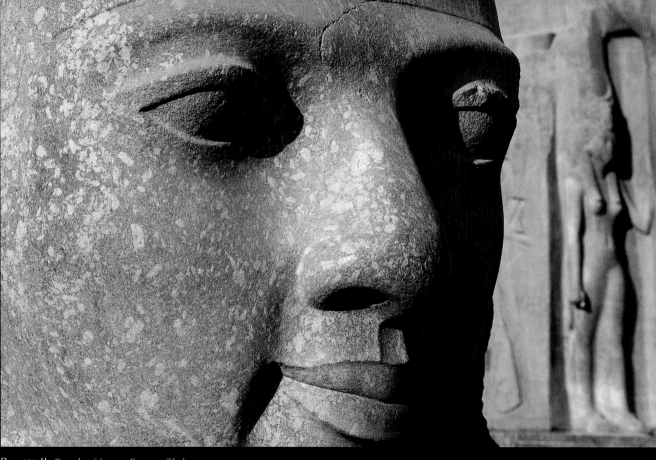

RAMSES II. *Temple of Luxor, Eastern Thebes.*

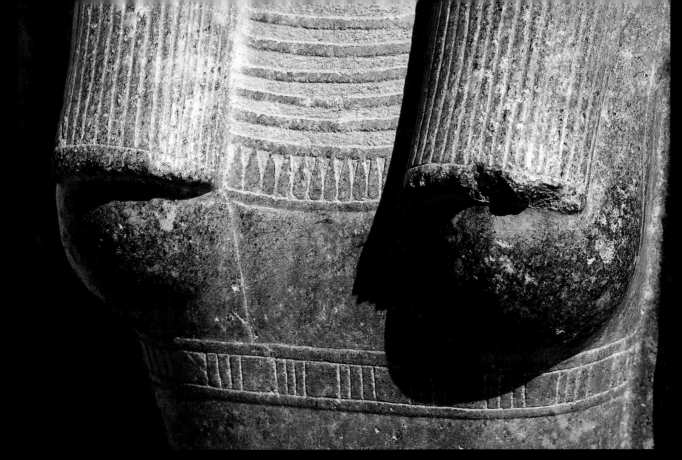

SEKHMET. *Temple of Ramses III at Madinat Habu. Western Thebes.*

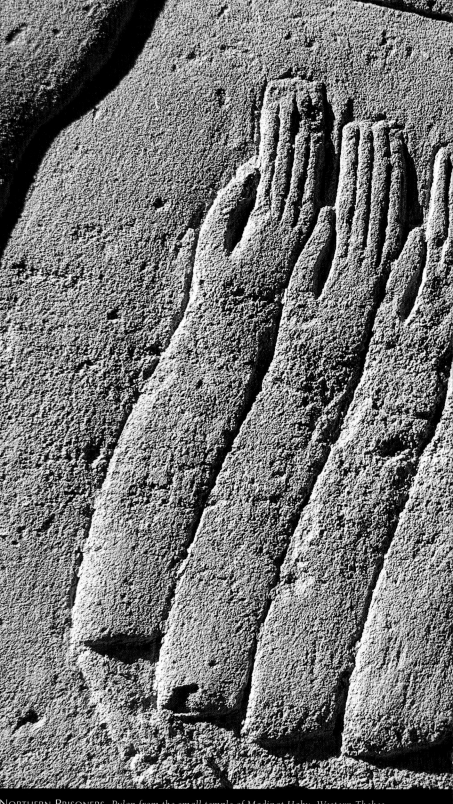

NORTHERN PRISONERS. *Pylon from the small temple of Madinat Habu. Western Thebes.*

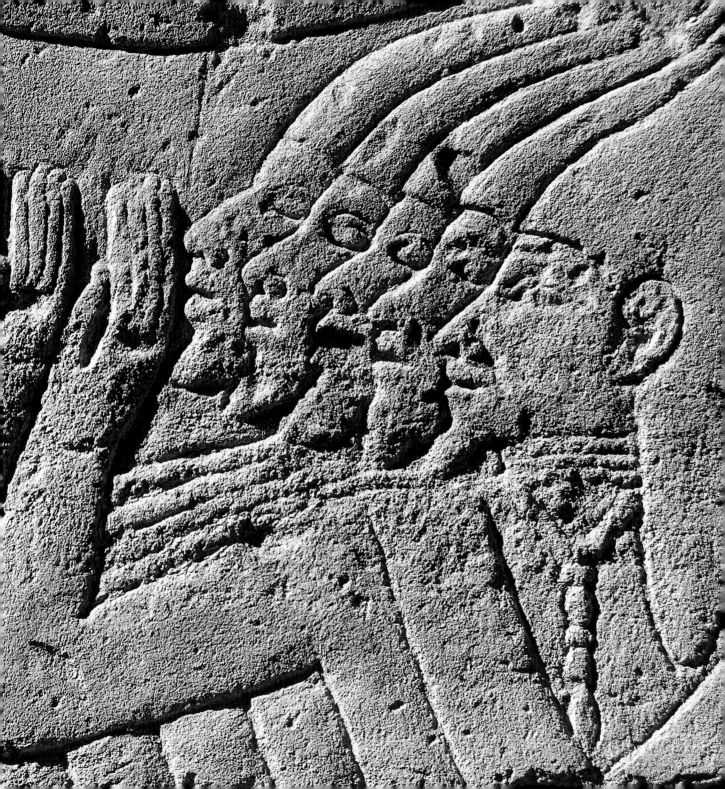

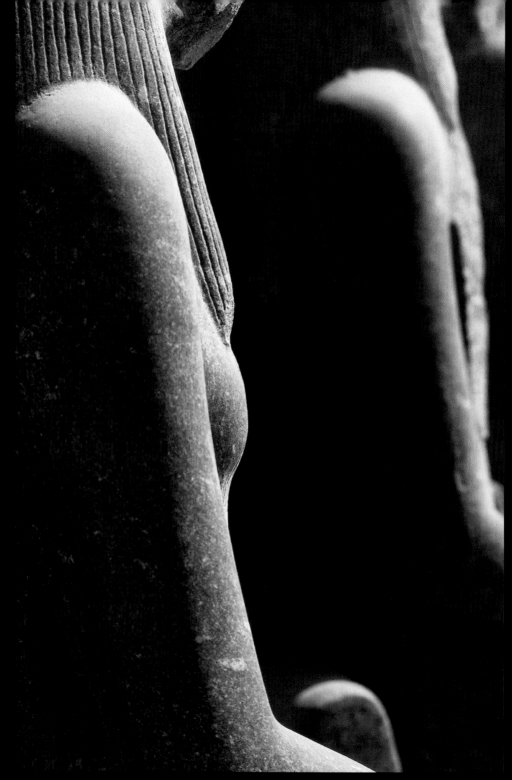

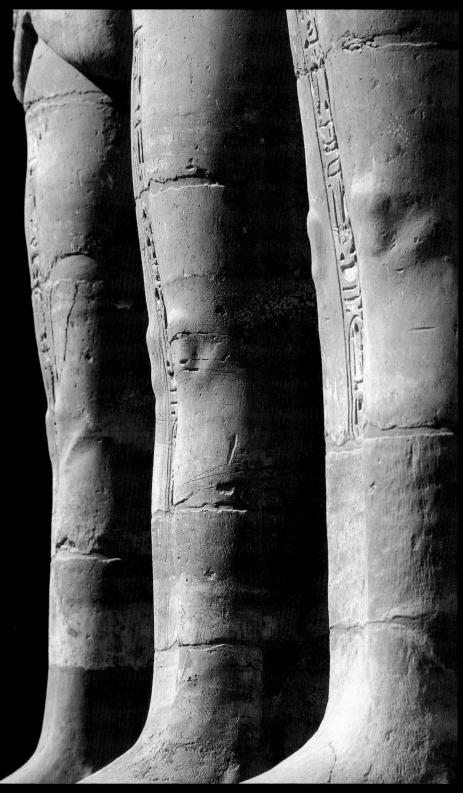

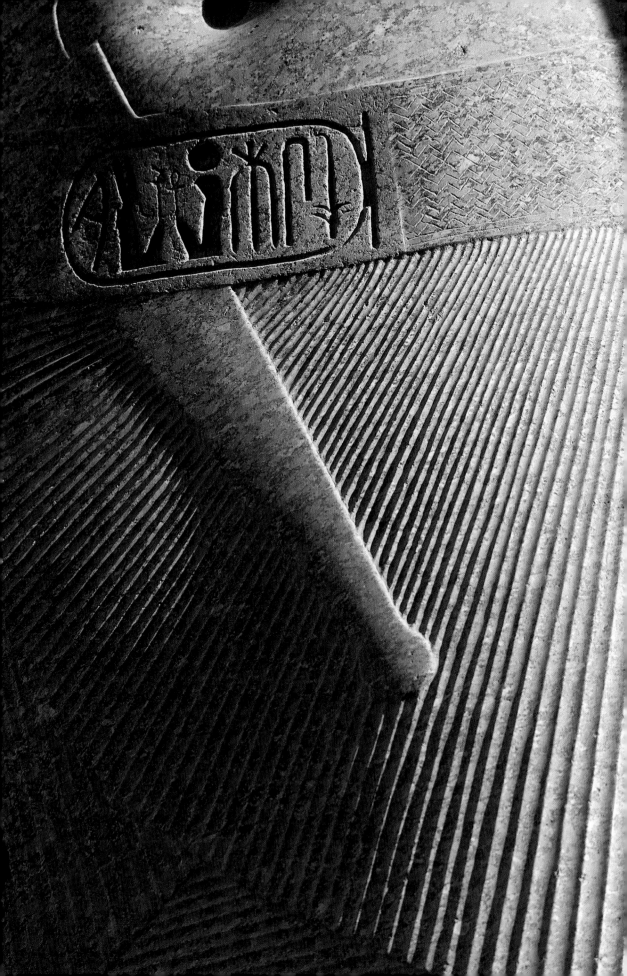

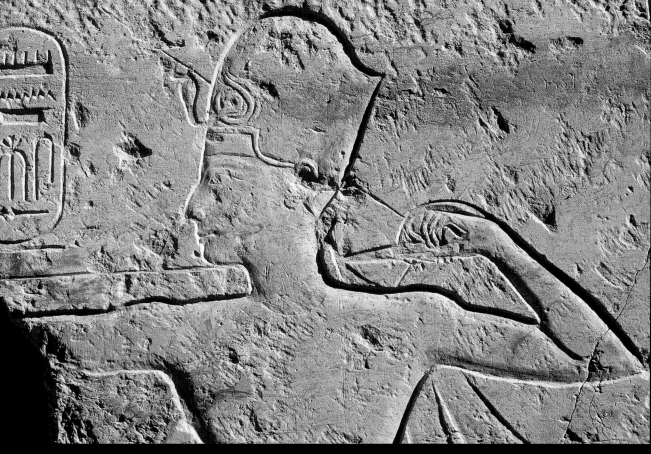

RAMSES II. *Speos Temple of Beit el-Wali, Nubia.*

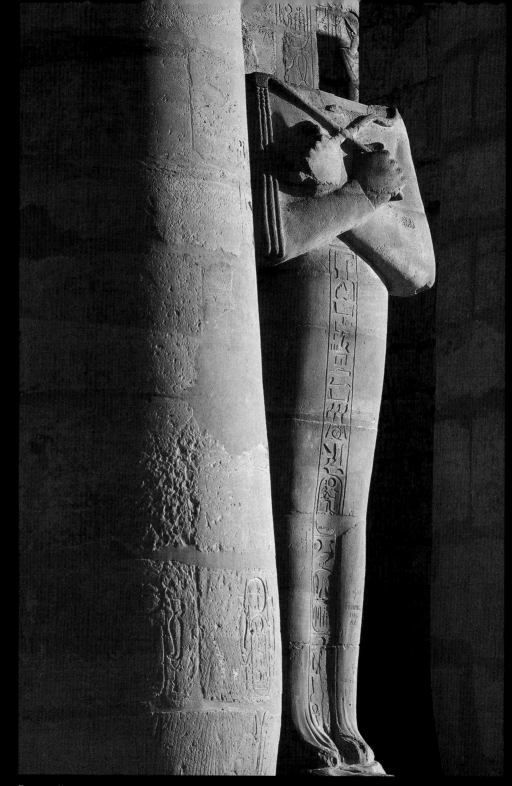

RAMSES II. *Rameseum. Western Thebes.*

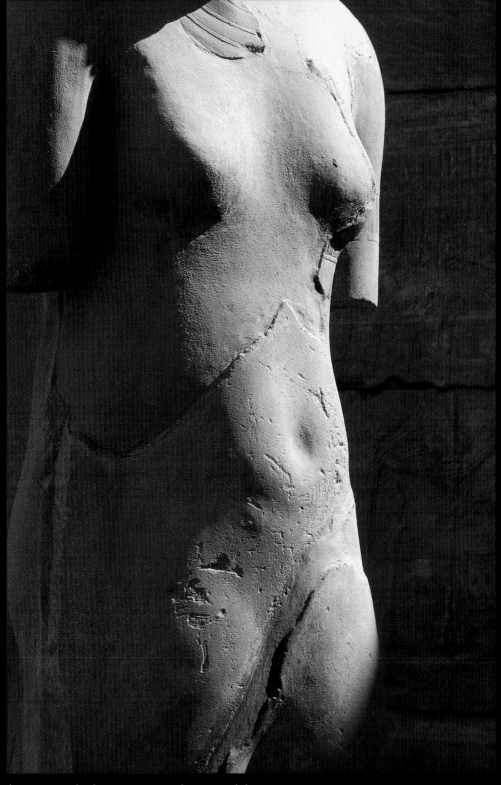

Amonit. *Temple of Amon Ra at Karnak. Eastern Thebes.*

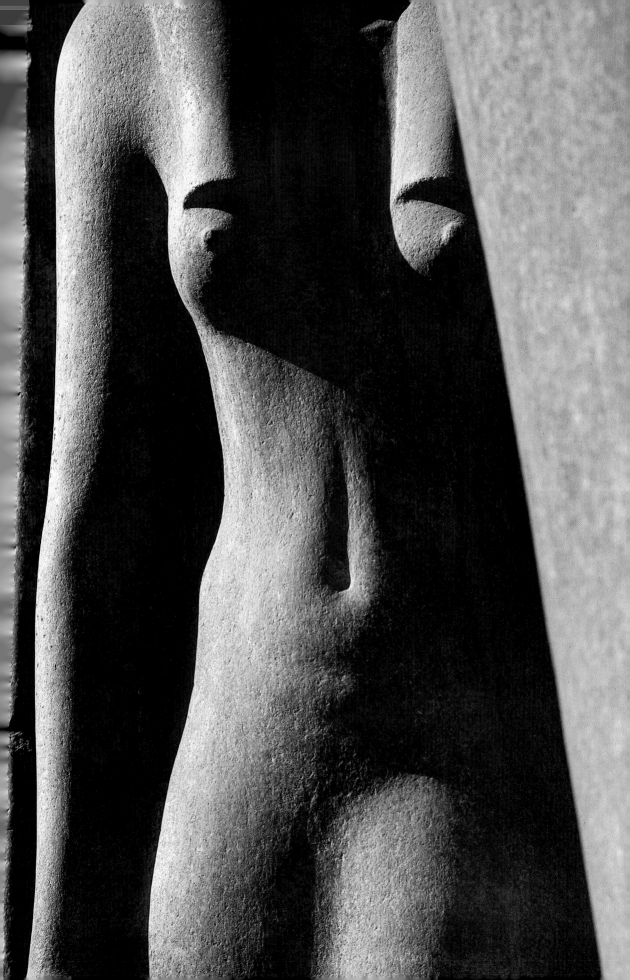

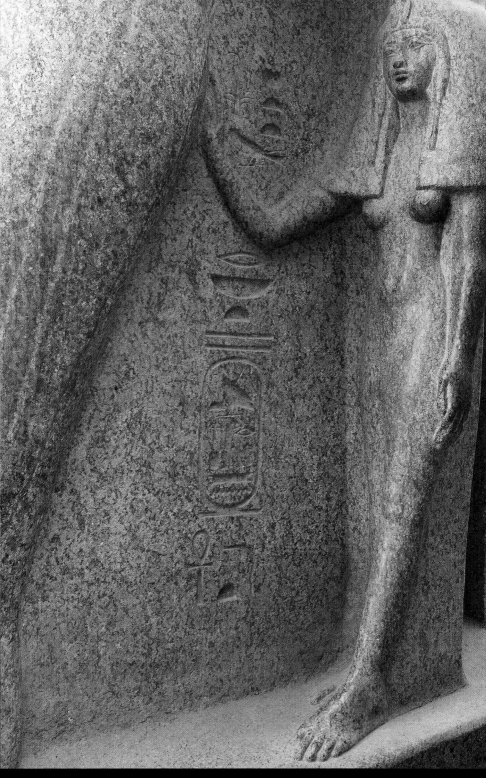

NOFRETARI (?). *Temple of Luxor. Eastern Thebes.*

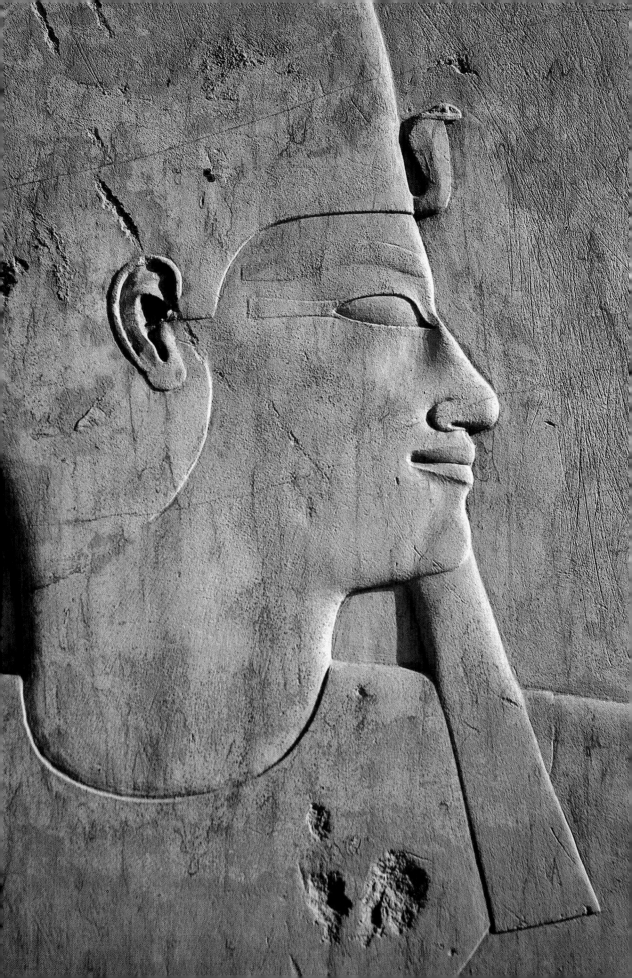

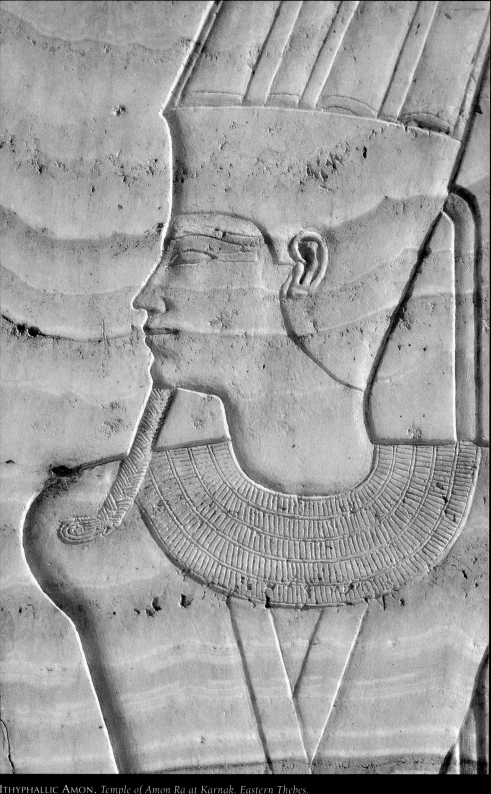

ITHYPHALLIC AMON. *Temple of Amon Ra at Karnak. Eastern Thebes.*

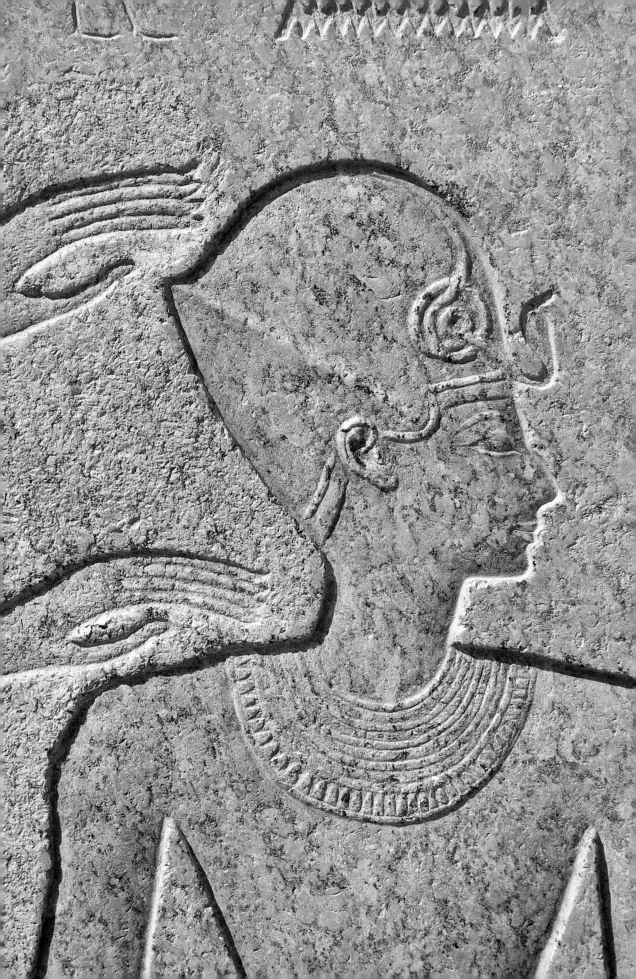

HATSHEPSUT AND AMON. *Bark-Shrine of Hatshepsut. Temple of Amon Ra at Karnak. Eastern Thebes.*

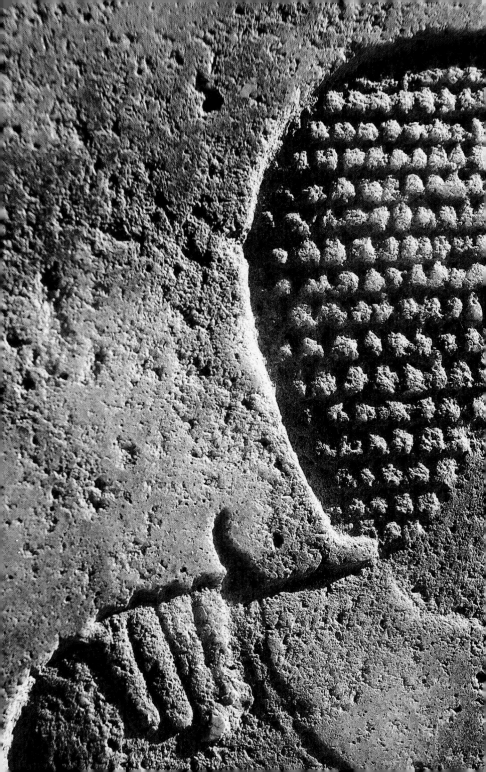

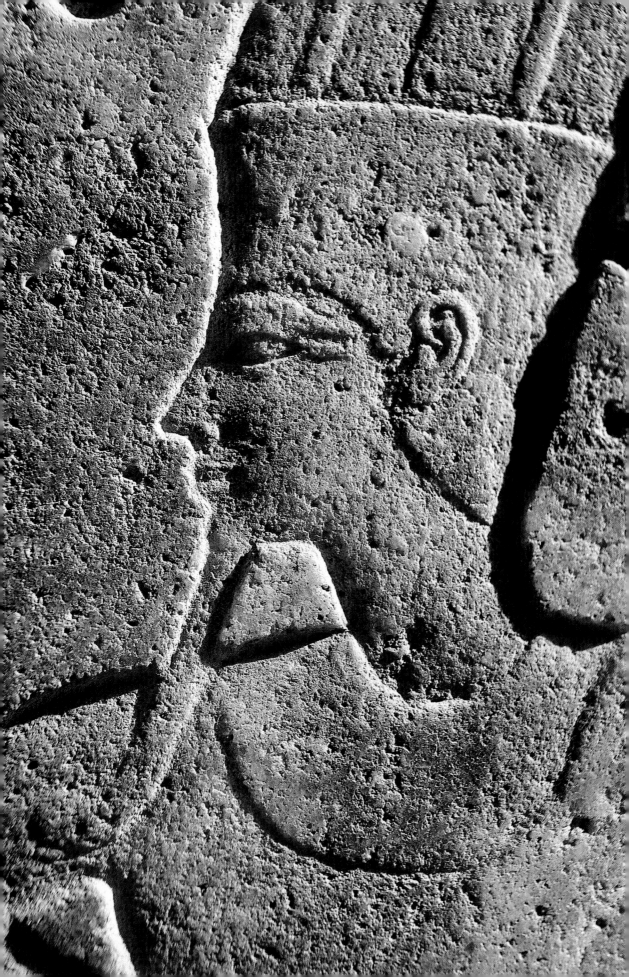

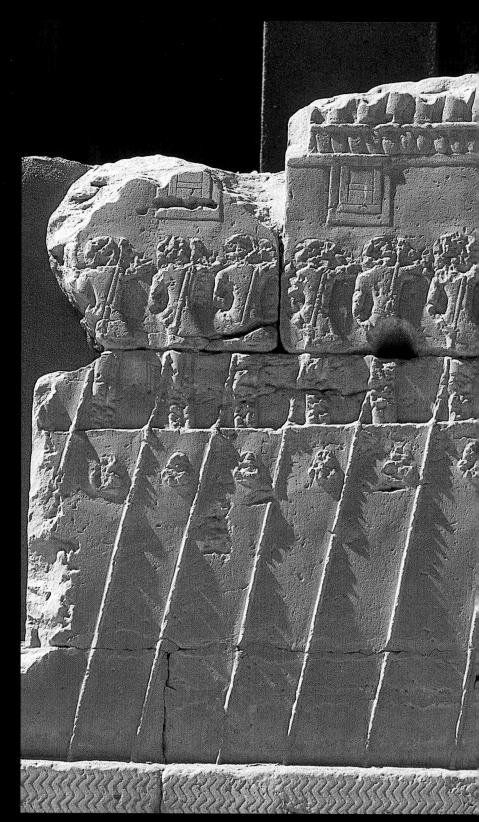

ROWERS. *Temple of Amon Ra at Karnak. Eastern Thebes.*

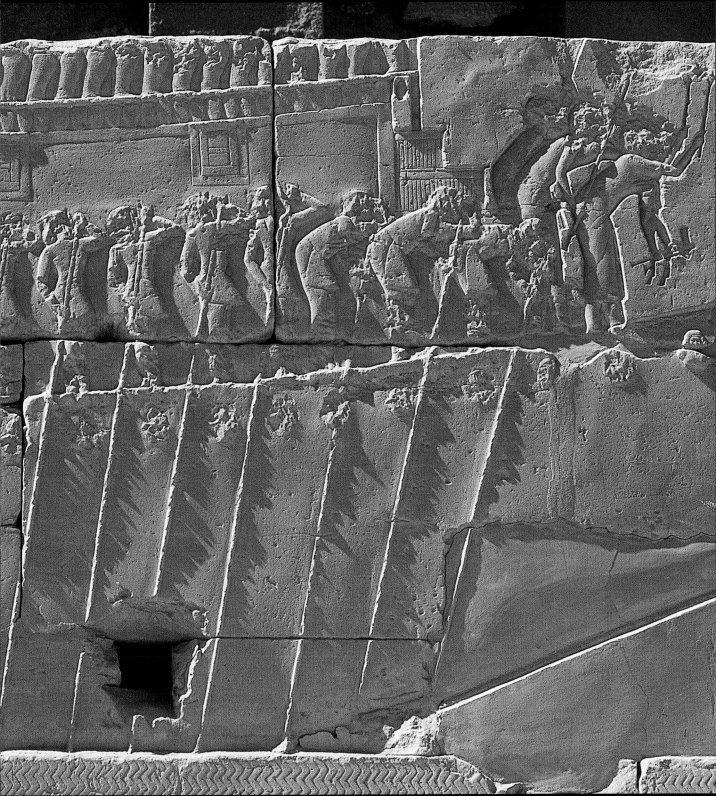

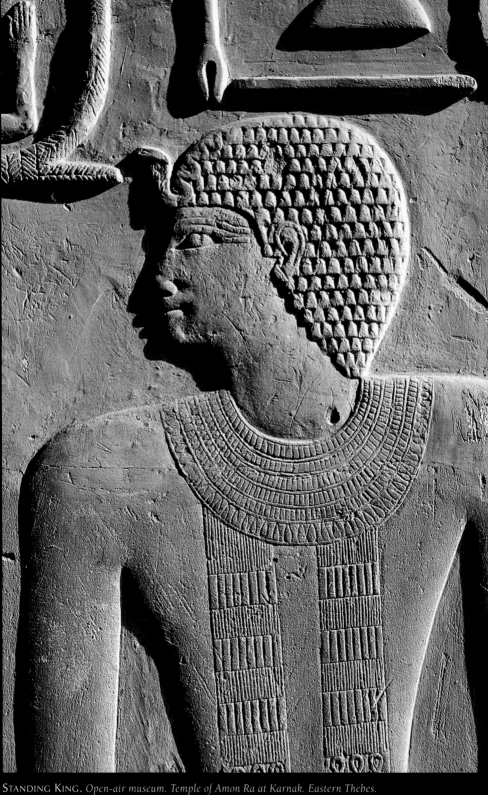

STANDING KING. *Open-air museum. Temple of Amon Ra at Karnak. Eastern Thebes.*
DETAIL OF THE TOMB OF KHAEMHAT. *Tomb Number 57. Necropolis of Sheikh Abd el-Gournah. Western Theb*

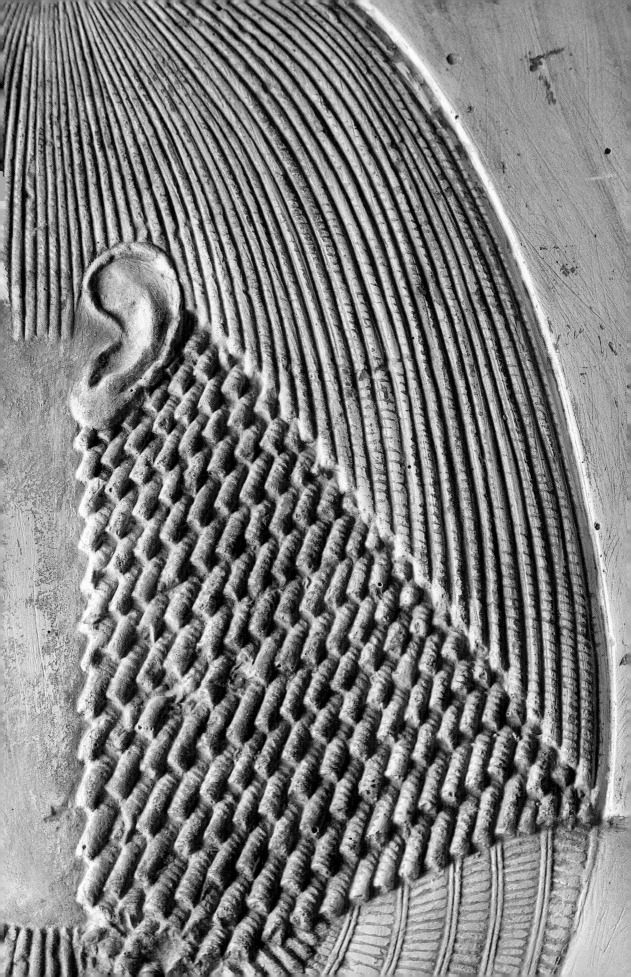

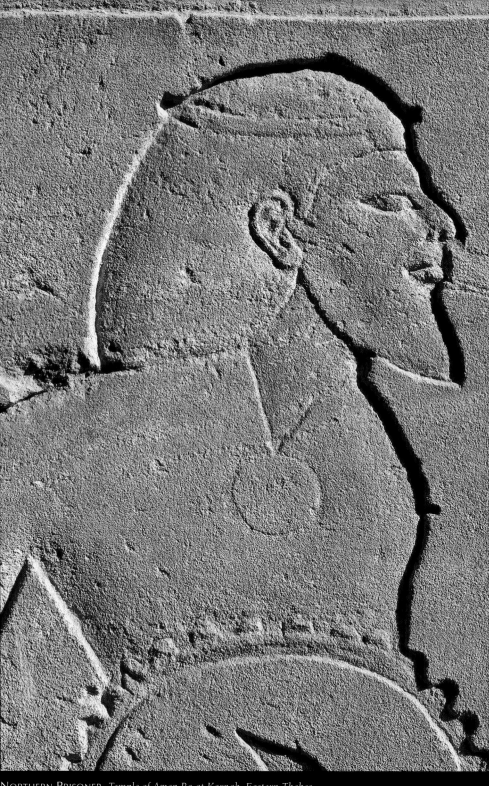

NORTHERN PRISONER. *Temple of Amon Ra at Karnak. Eastern Thebes.*

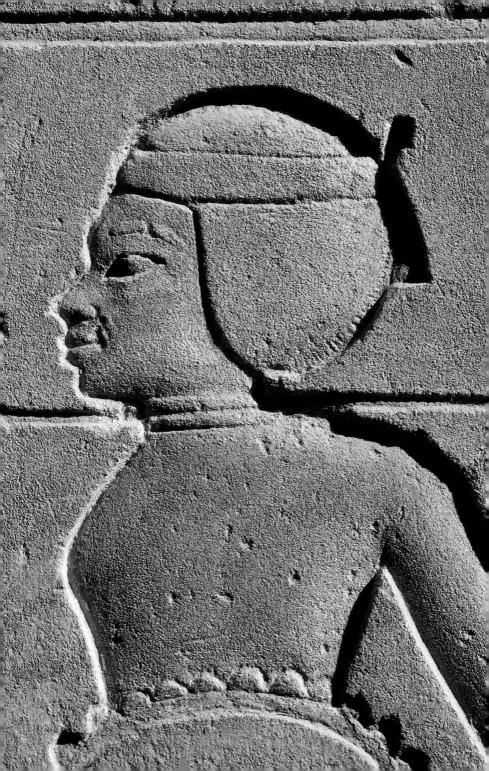

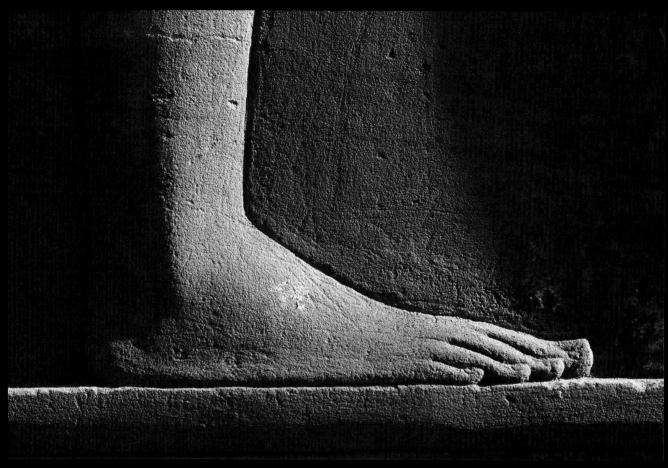

Foot. *Temple of Sobek and Haroeris at Kom Ombo.*

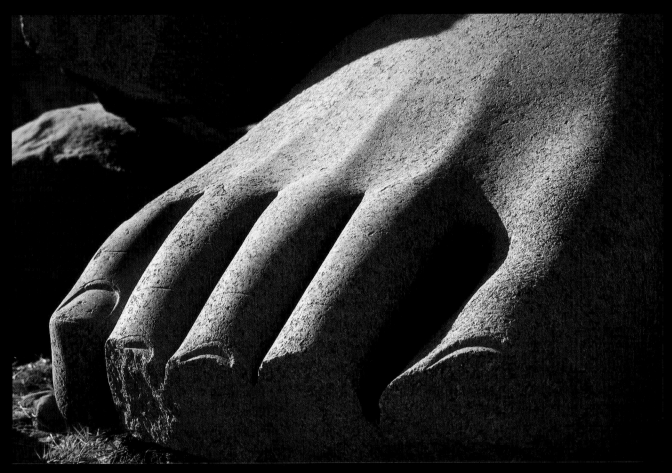

ROYAL FOOT. *Rameseum. Western Thebes.*

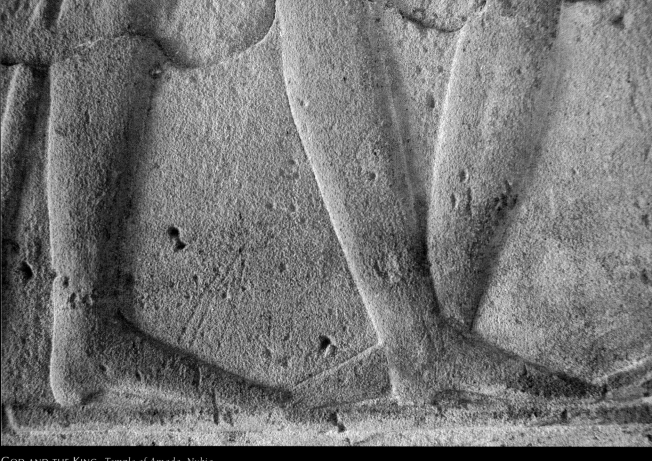

GOD AND THE KING. *Temple of Amada, Nubia.*

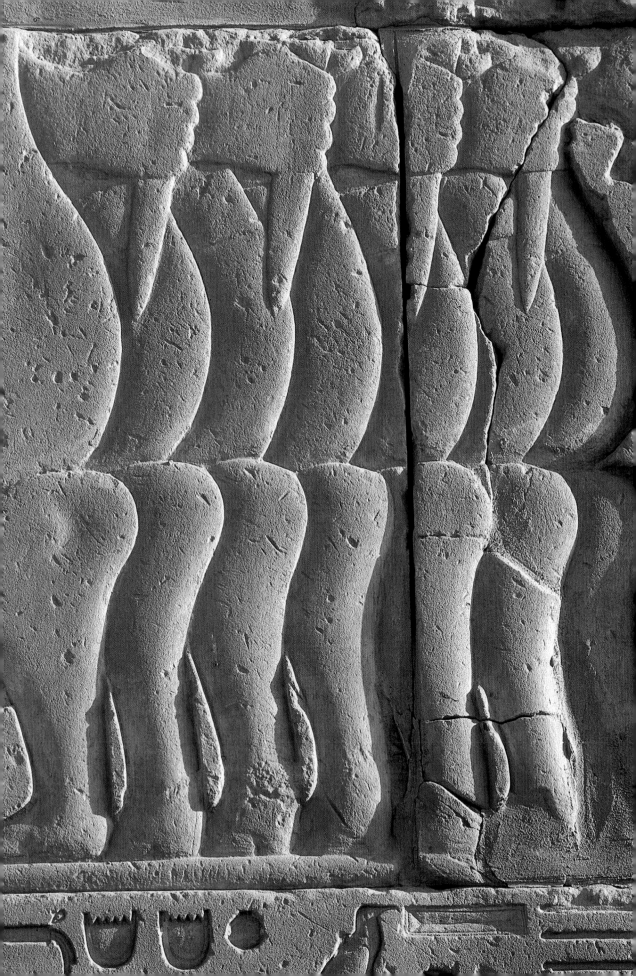

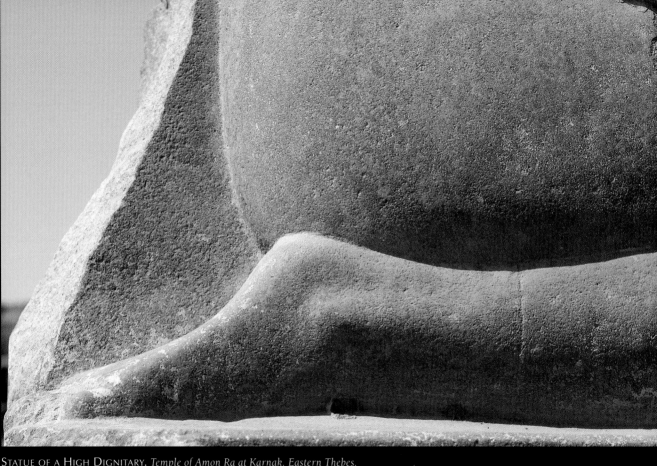

STATUE OF A HIGH DIGNITARY. *Temple of Amon Ra at Karnak. Eastern Thebes.*

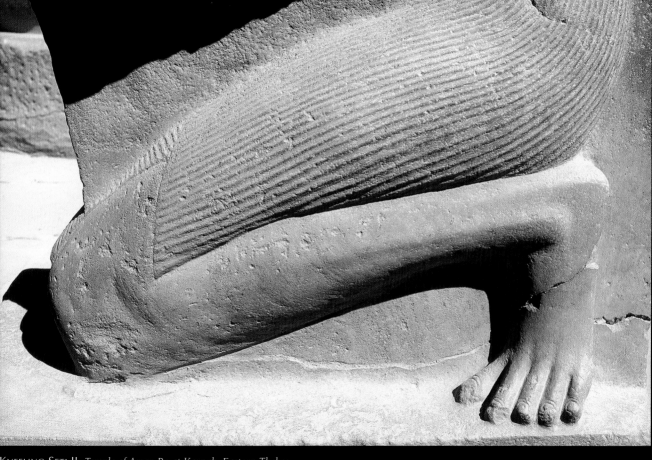

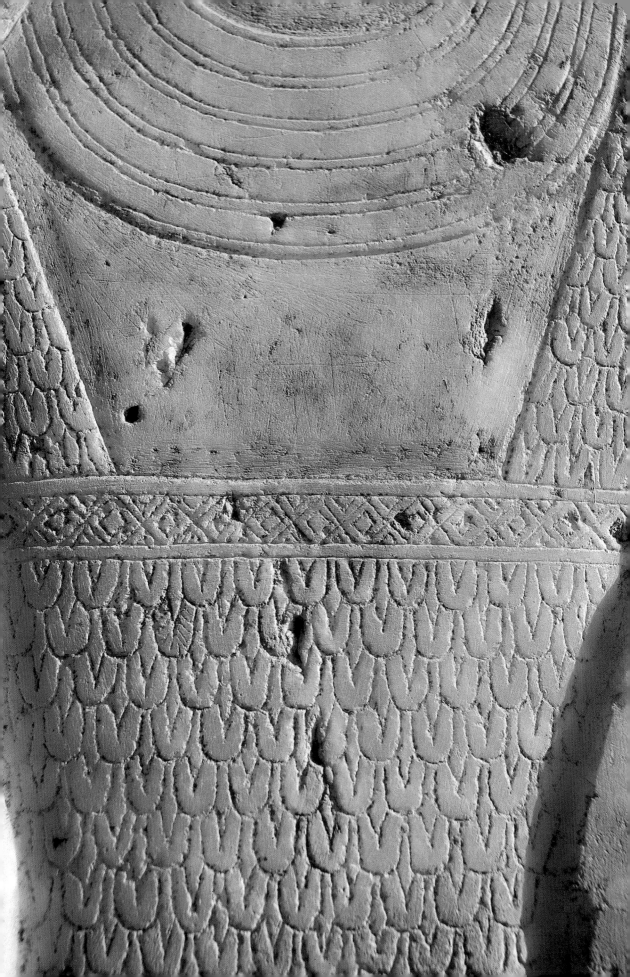

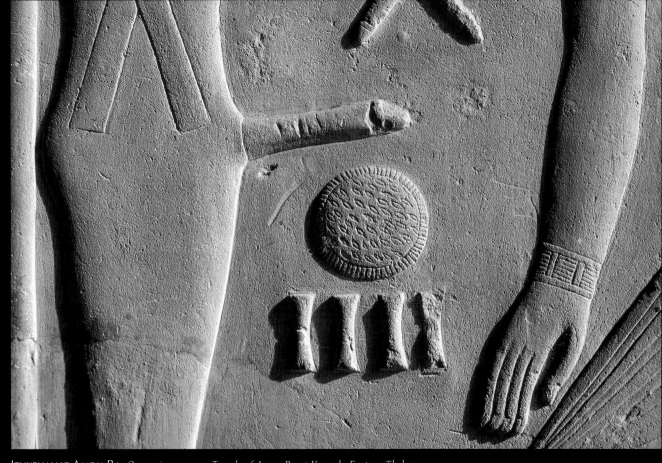

ITHYPHALLIC AMON RA. *Open-air museum. Temple of Amon Ra at Karnak. Eastern Thebes.*

◄ AMON. *Open-air museum. Temple of Amon Ra at Karnak. Eastern Thebes.*

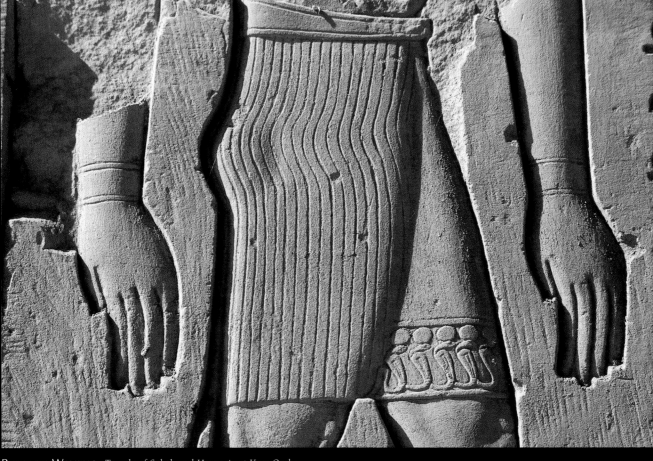

PHARAOH WALKING. *Temple of Sobek and Haroeris at Kom Ombo.*

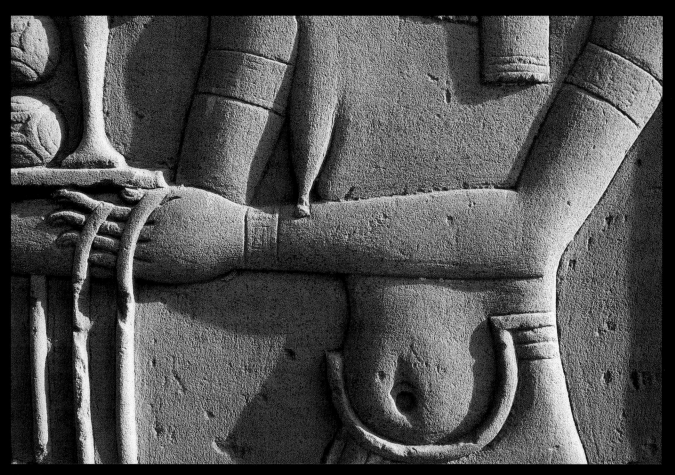

NILE GOD. *Temple of Sobek and Haroeris at Kom Ombo.*

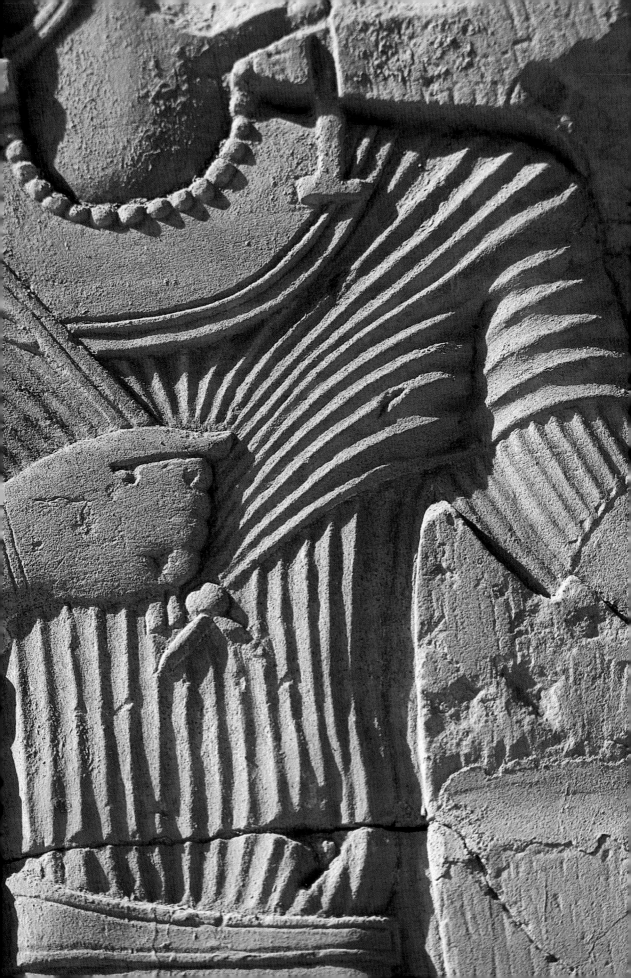

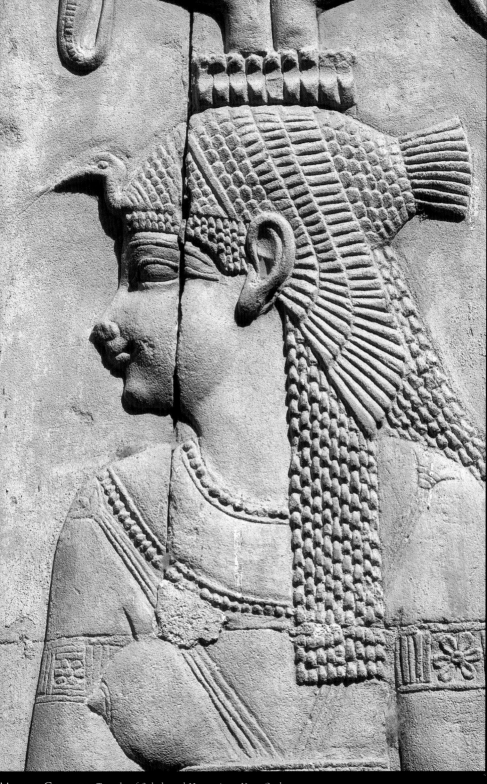

MOTHER GODDESS. *Temple of Sobek and Haroeris at Kom Ombo.*

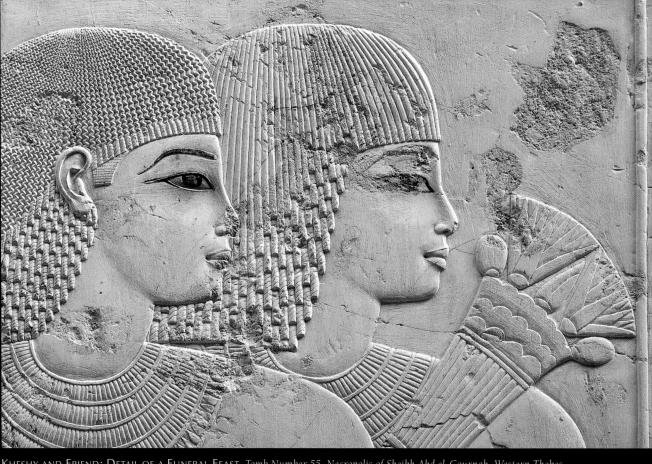

KHESHY AND FRIEND; DETAIL OF A FUNERAL FEAST. *Tomb Number 55. Necropolis of Sheikh Abd el-Gournah. Western Thebes.*
PAPYRUS BEARER. *Tomb Number 55. Necropolis of Sheikh Abd el-Gournah. Western Thebes.* ▶

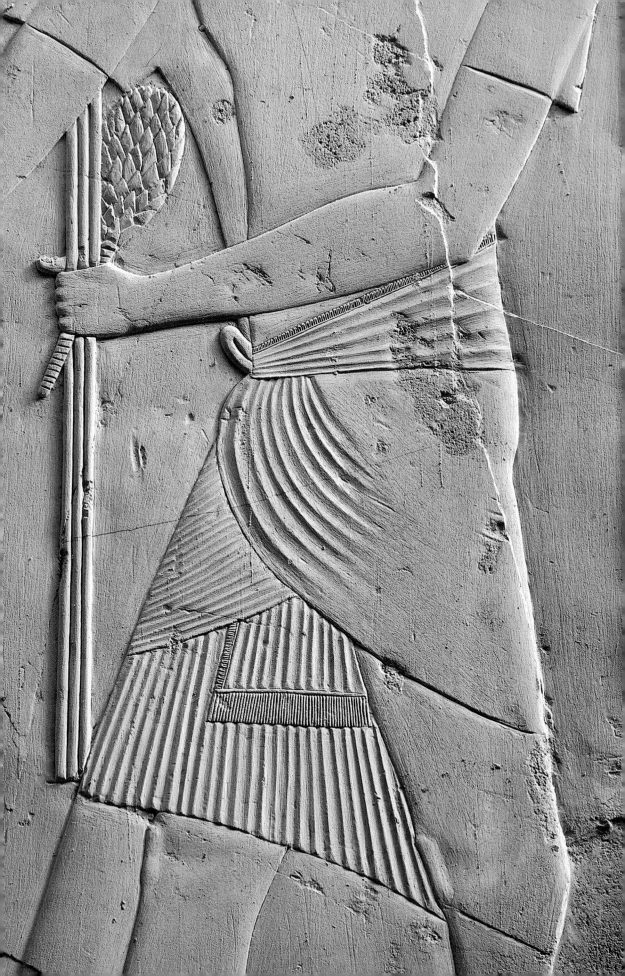

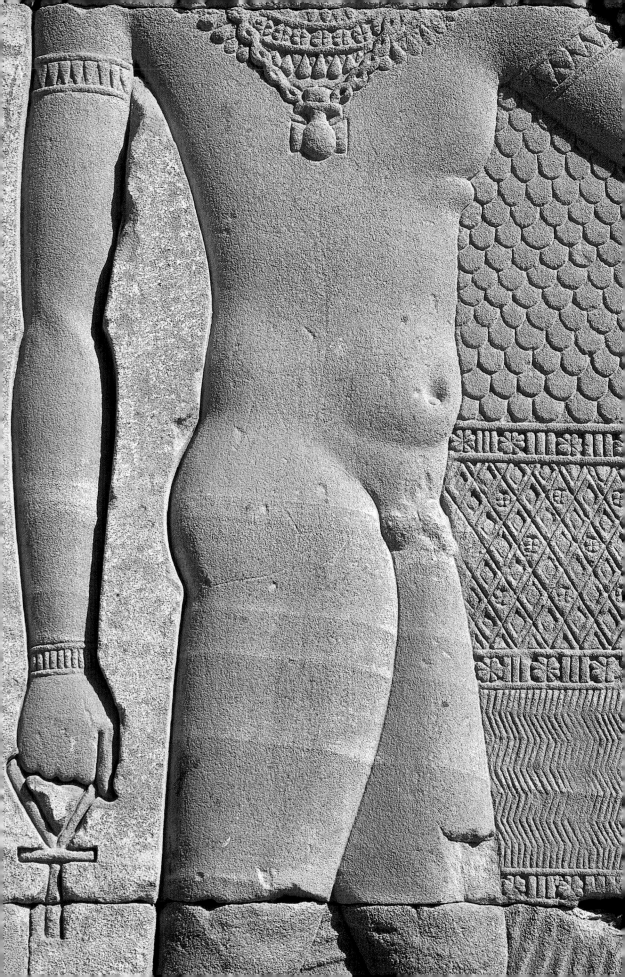

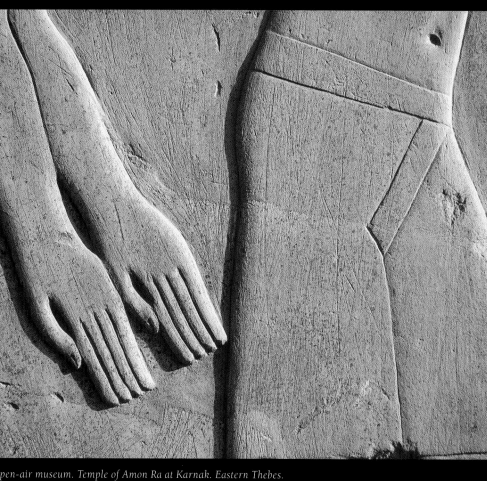

pen-air museum. Temple of Amon Ra at Karnak. Eastern Thebes.

ITHYPHALLIC AMON RA. *Open-air museum. Temple of Amon Ra at Karnak. Eastern Thebes.* ▶

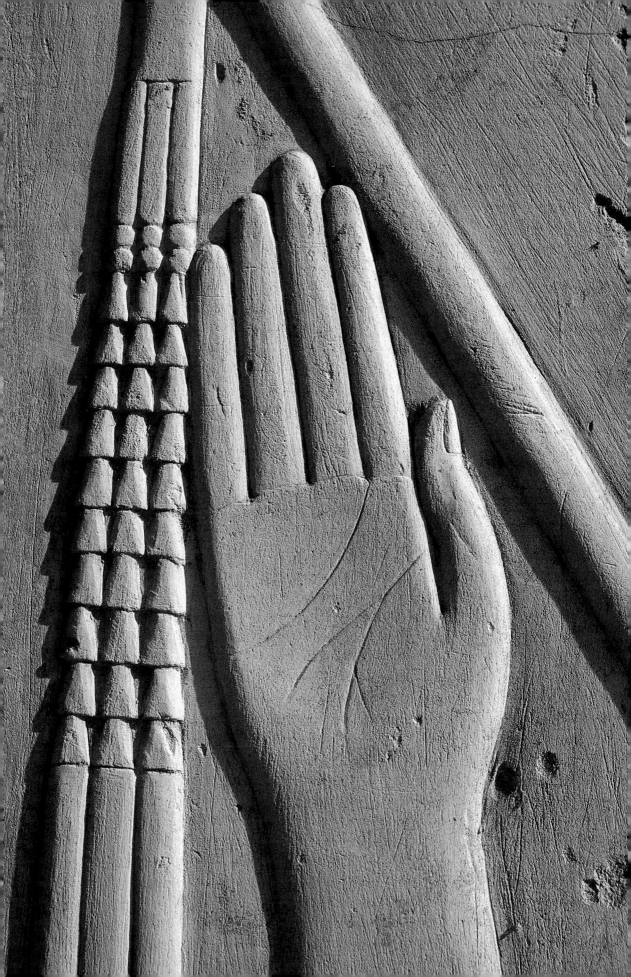

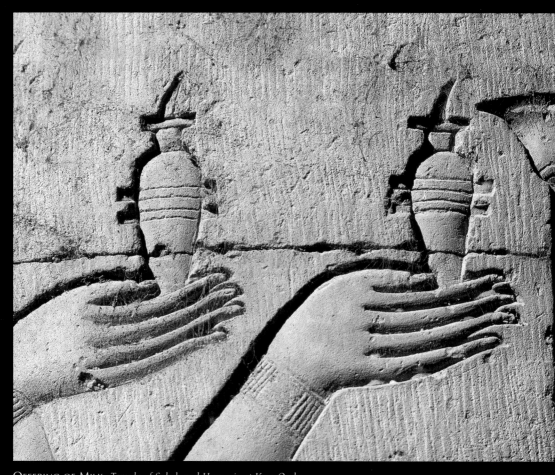

OFFERING OF MILK. *Temple of Sobek and Haroeris at Kom Ombo.*

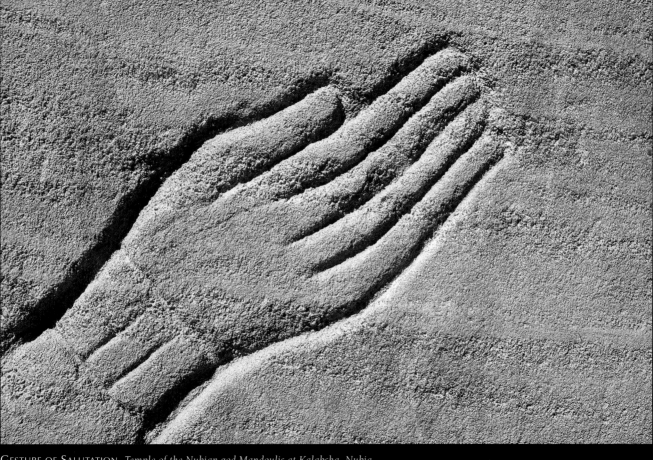

GESTURE OF SALUTATION. *Temple of the Nubian god Mandoulis at Kalabsha, Nubia.*

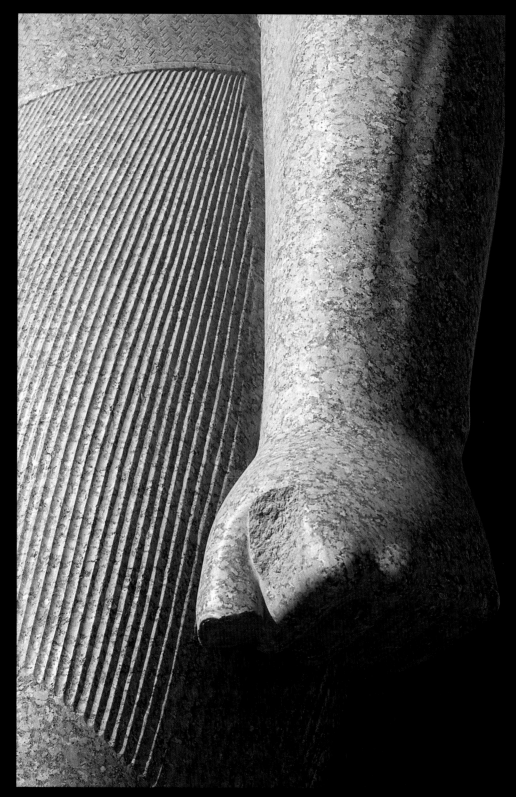

RAMSES II. *Temple of Luxor. Eastern Thebes.*

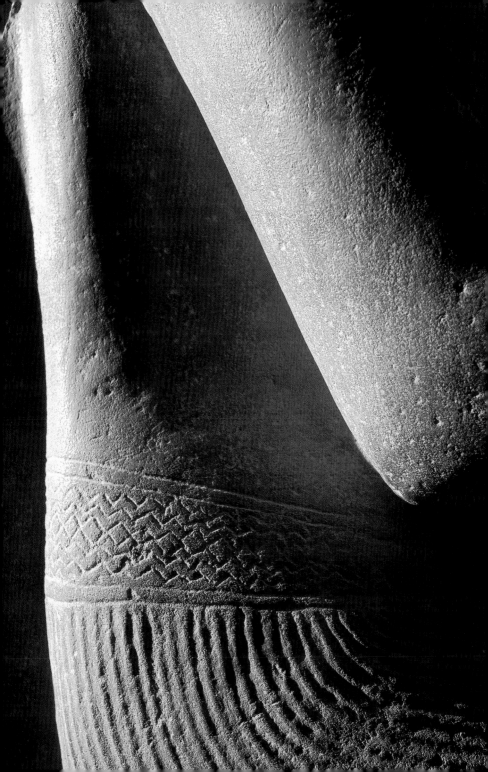

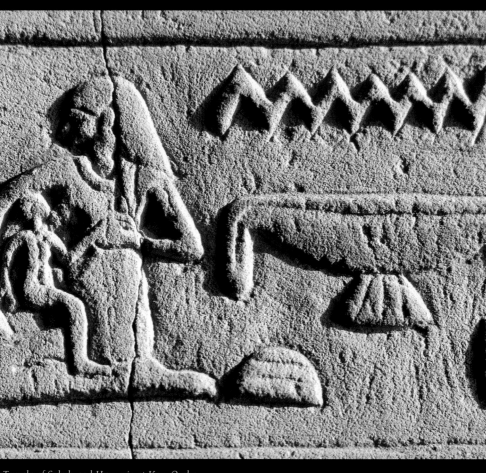

Temple of Sobek and Haroeris at Kom Ombo.

Roman Mammisi of the temple of Hathor at Dendera. ▶

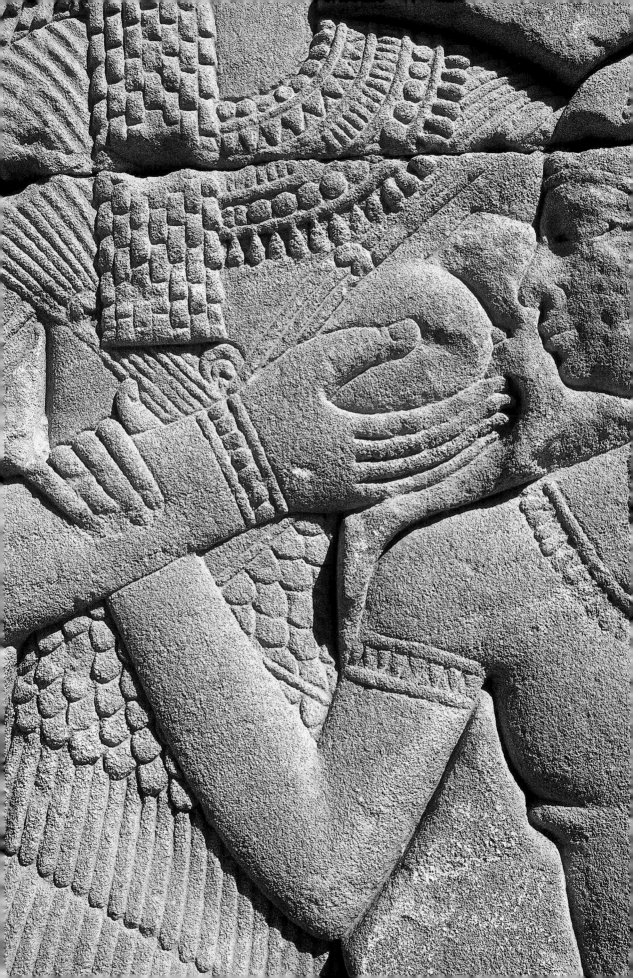

THE ANIMAL WORLD

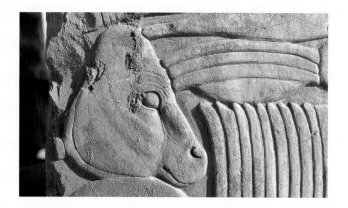

In ancient Egypt, the Egyptians used their fertile imaginations to transform the animals that surrounded them into a divine bestiary. They ascribed to the deities the faces they saw flying in the sky, walking on the earth, or flashing in the clear waters of the Nile. Though true gods and goddesses, they were at the same time also wild creatures—mammals, birds, and reptiles—with the bodies of men or women or in their natural animal form. Incarnated in numerous reliefs and statues, they haunt the Egyptian temples.

Were the Egyptians animal worshipers, or did they simply assign their own qualities and faults to them? Their ideas about animals strongly correspond to the signs of the zodiac familiar today in horoscopes: we see the force and beauty of a lion, the strength of a ram, and the reserve of a scorpion.

These divinities had names: Hathor, the nurturing cow; Horus, the falcon protector of royalty; Isis, the bird wife of Osiris, mother of Horus and a great magician; Mut, the vulture whose name is at the root of the word mother, or in German, *Mutter.* Sekhmet was the ferocious lioness that returned from Nubia, soothed like the beneficial flood;

Selkit, the scorpion, protected one of the canopic vases; and there was Sobek, the crocodile, "who arises from the waves like the sun." Some of the animals were good or evil, depending on their sex. The male hippopotamus was so malevolent that he was kept at the bottom of the water; the female, on the other hand, had qualities so beneficial that she acted as a midwife during childbirth.

The majority of bird goddesses shielded the bodies of the gods and goddesses, and thus also the kings and queens, with their plumage. The soaring flight of Nekhbet the vulture decorates the ceilings of the processional alleys of the temples. The *uraeus*, or cobra, spit her venomous poison at all evildoers and thus protected the pharaoh's forehead, or the top of the temple screenwalls.

Sphinxes were the guardians of the sanctuary. Placed to one side and the other of the entry, they formed a *dromos*. Their lion bodies were often topped with the head of a ram or a falcon. When they were topped by a human face, it was that of the pharaoh.

These gods were ambiguous, sometime defenders with the capacity to become assailants, too. According to legend, Sekhmet the ferocious lioness always haunted Karnak at night. With the exception of unwary tourists, few villagers were willing to take a nocturnal promenade through the temple grounds. Some, like Selkit, had a dangerous sting. But humans, who created this universe, were wise enough to build safeguards into it, such as prayers and incantations, prostrations, and sacrifice.

The animals also had the great power to metamorphose. Thoth, god of wisdom and patron of scribes, could either be a baboon or an ibis. Hathor was confused with Sekhmet. The falcon had numerous godly identities, and only the inscribed names and the headwear differentiate the divine beings. As a solar god the falcon is Horus but can also be Ra, his father; this bird of prey also provides the face for Montu, the god of war, or Sokaris, the mummified falcon.

Beyond the divine world, there were the representations of domestic and wild animals, even more minutely detailed. If god or man could be lightly sketched, animals had to be depicted with all their distinctive markings. We see them struggling in the reed thickets or as offerings and even in the form of pharaonic hieroglyphic characters.

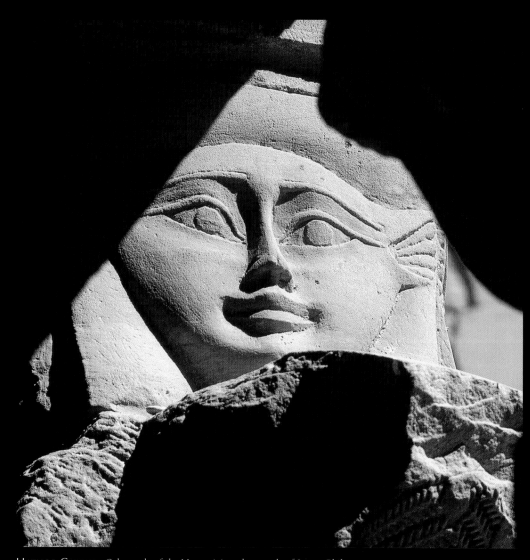

HATHOR CAPITAL. *Colonnade of the* Mammisi *at the temple of Isis at Philae.*
SISTRUM COLUMN. *Temple of Hatshepsut at Dayr al-Bahri. Western Thebes.* ▶

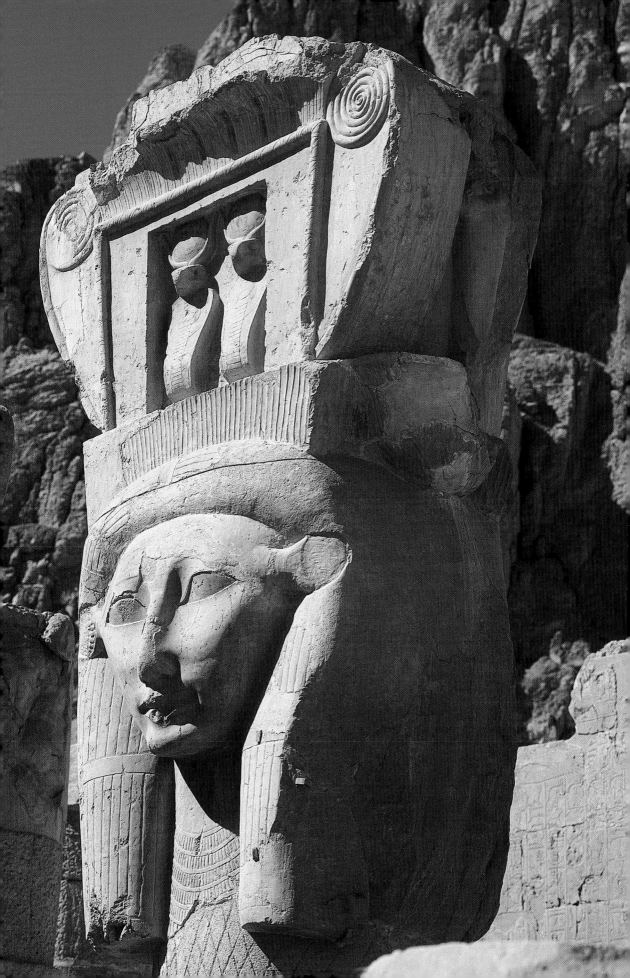

◄ SEKHMET. *Ten*
Eastern Thebes.
SEKHMET. *Open-*
Ra at Karnak. Ea

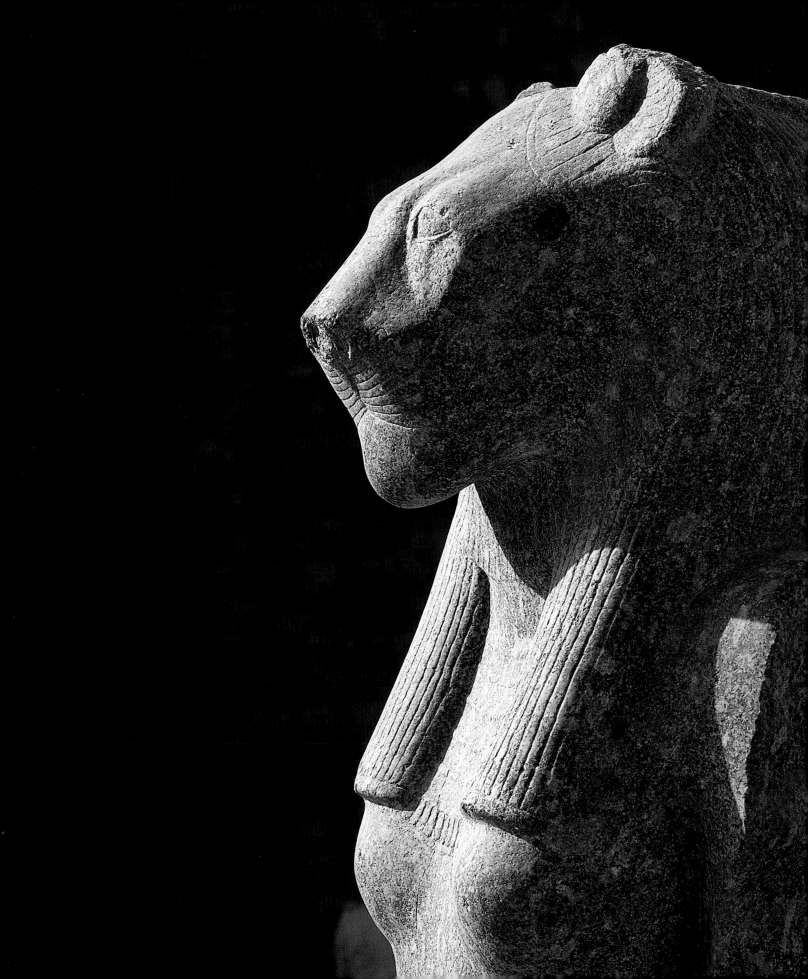

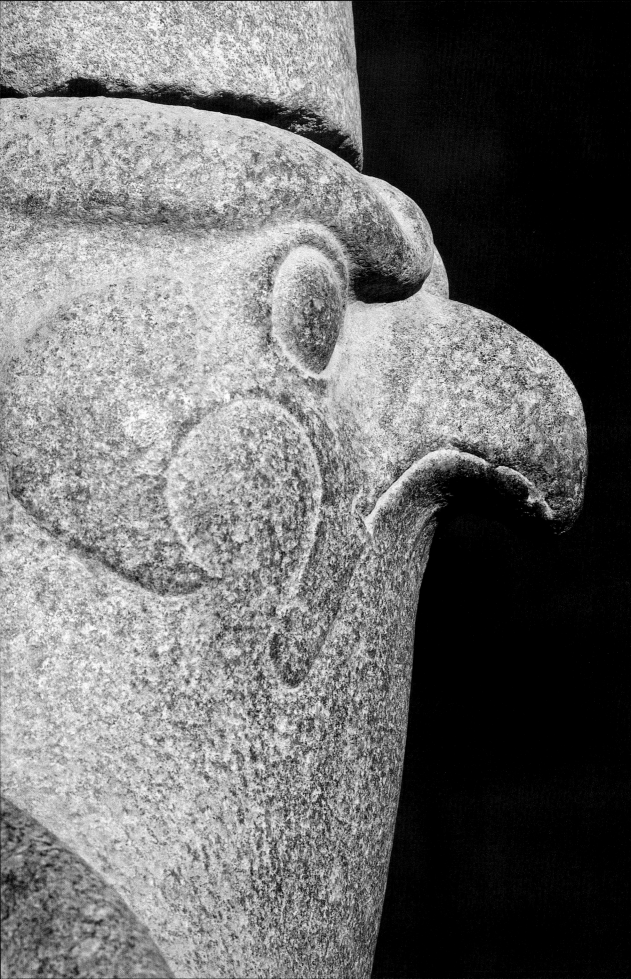

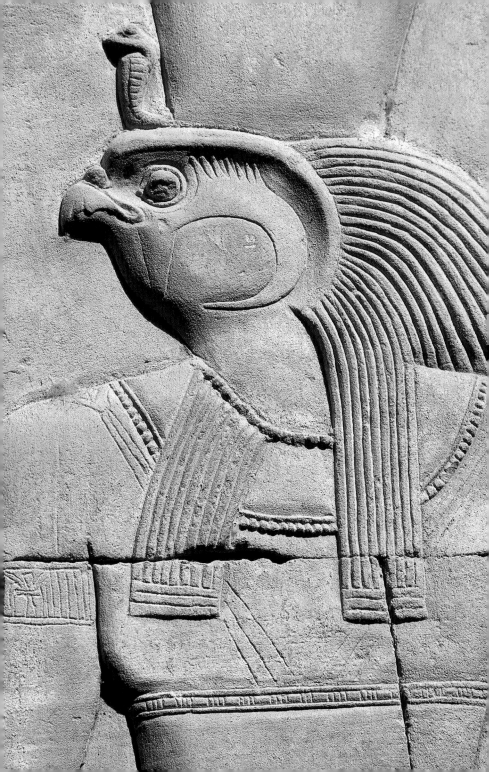

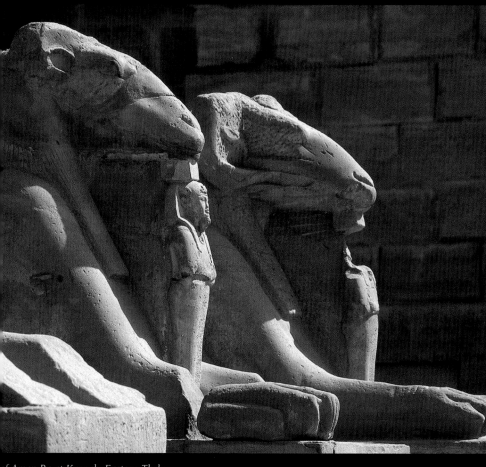

of Amon Ra at Karnak. Eastern Thebes.

of Luxor. Eastern Thebes. ▶

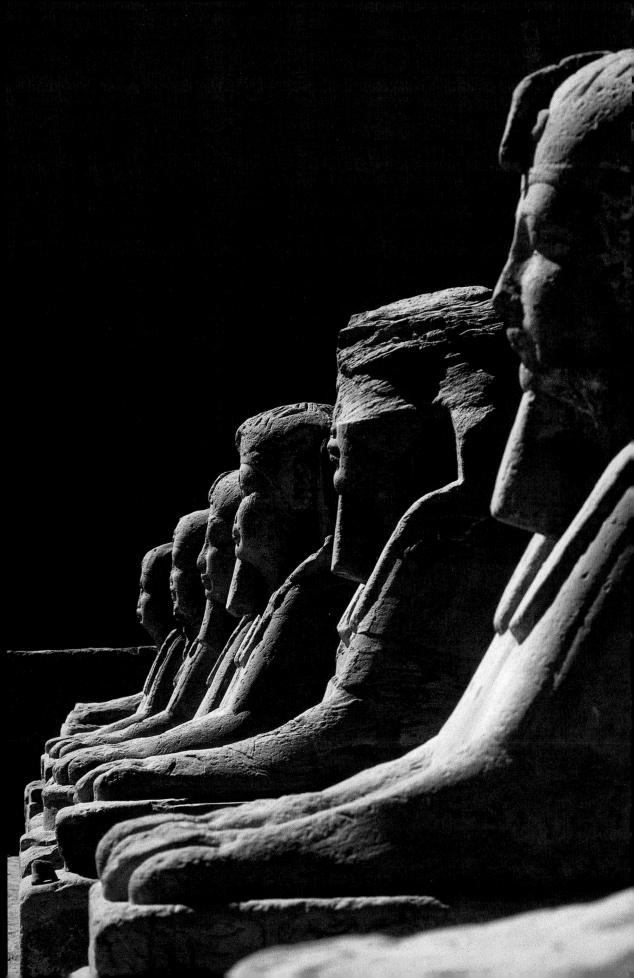

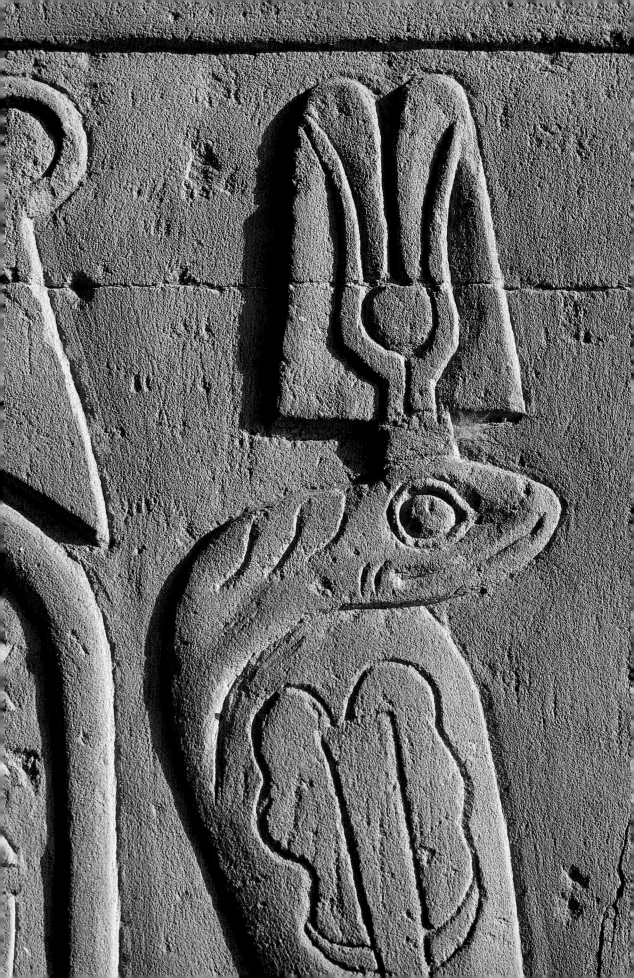

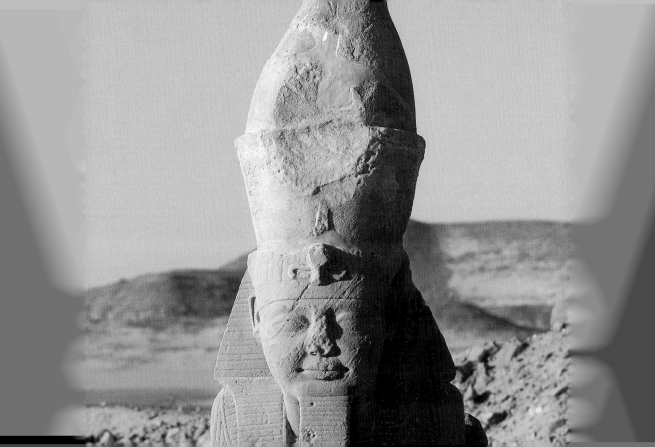

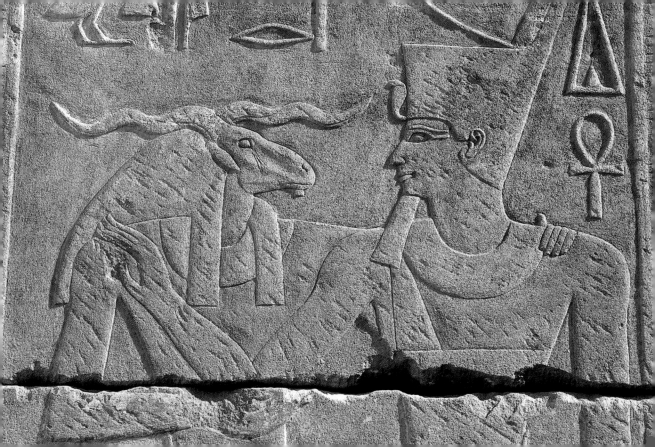

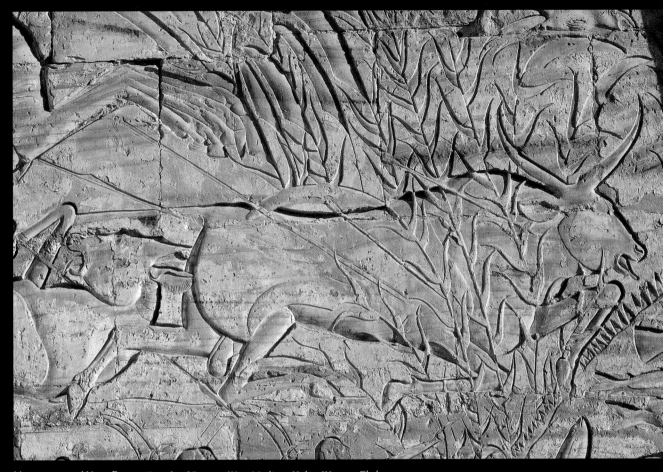

HUNT OF THE WILD BULLS. *Temple of Ramses III at Madinat Habu. Western Thebes.*

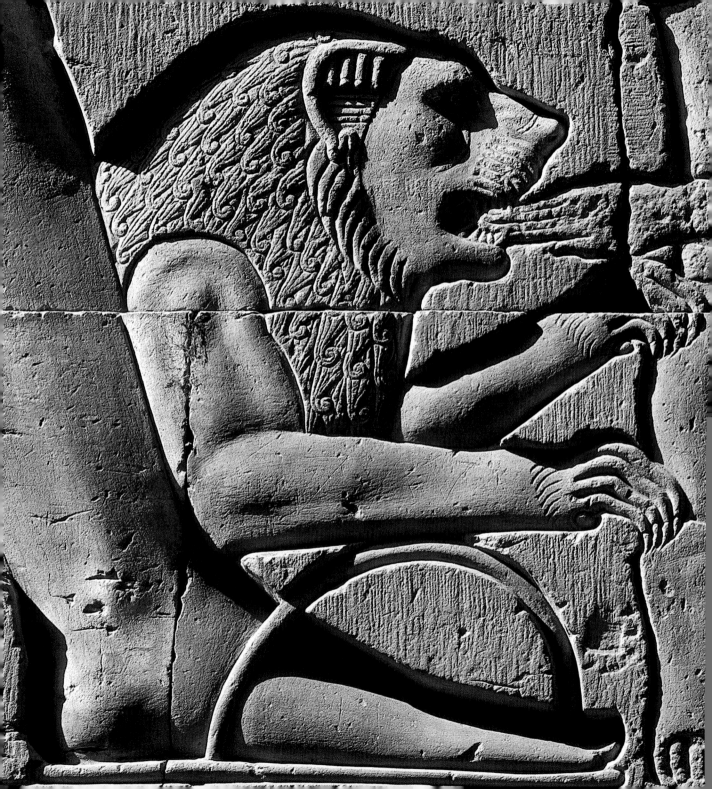

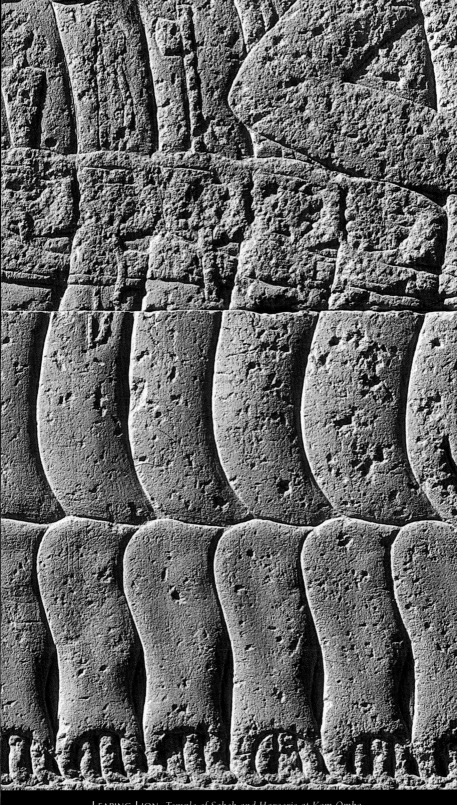

LEAPING LION. *Temple of Sobek and Haroeris at Kom Ombo.*

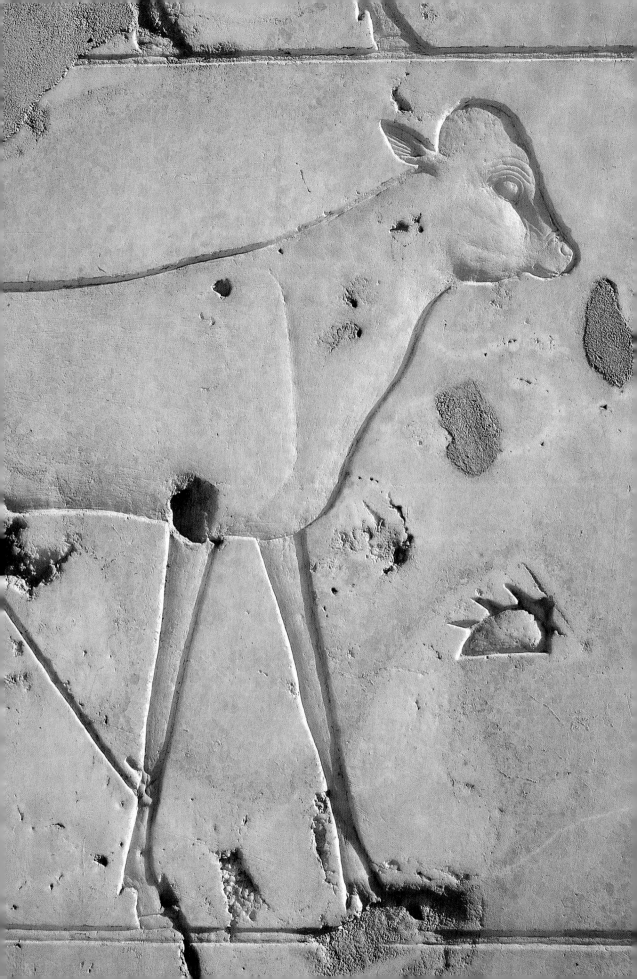

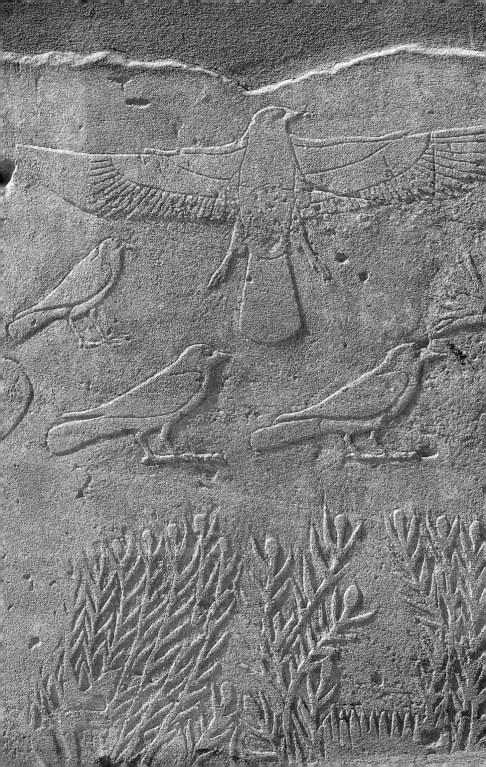

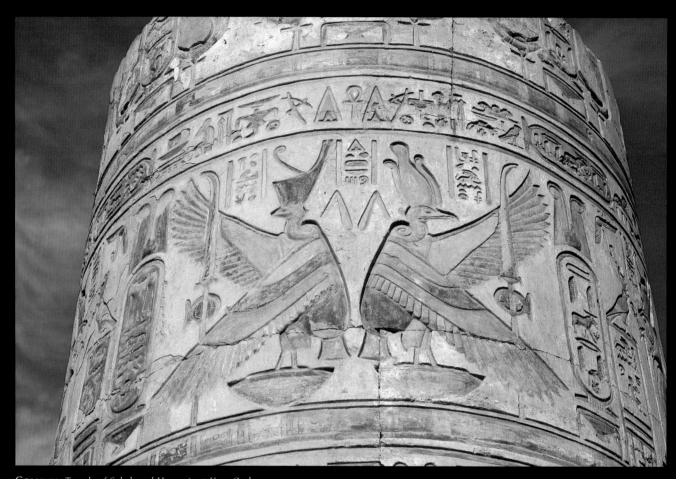

COLUMN. *Temple of Sobek and Haroeris at Kom Ombo.*

QUAIL CHICK. *Open-air museum. Temple of Amon Ra at Karnak. Eastern Thebes.* ▶

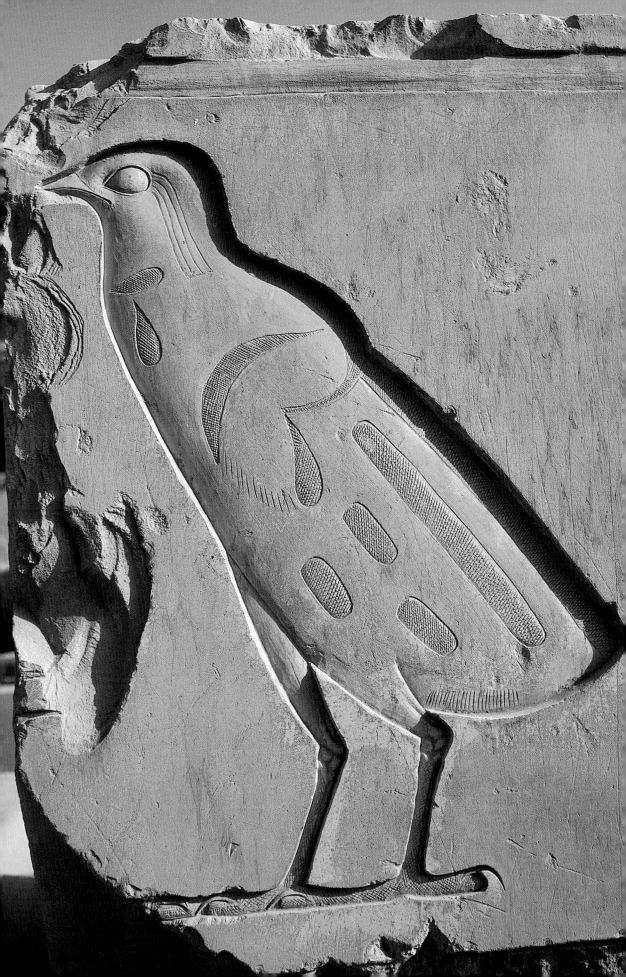

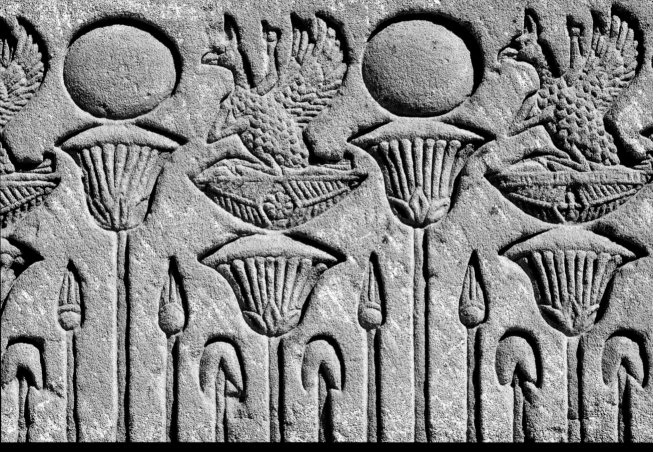

Rekhyt. Mammisi of the temple of Hathor at Dendera.

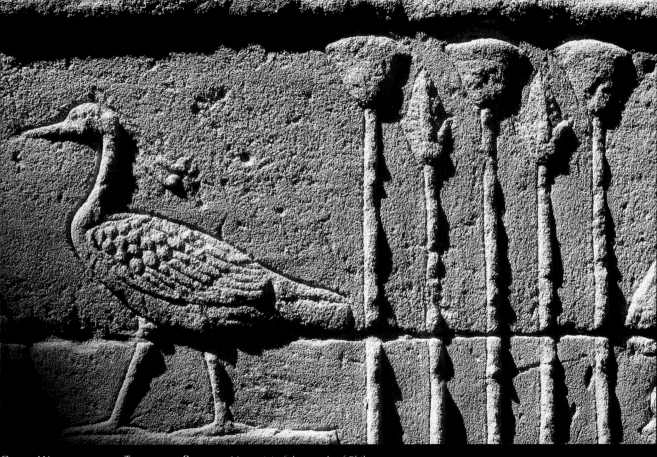

GOOSE WALKING NEAR A THICKET OF PAPYRUS. Mammisi *of the temple of Philae.*

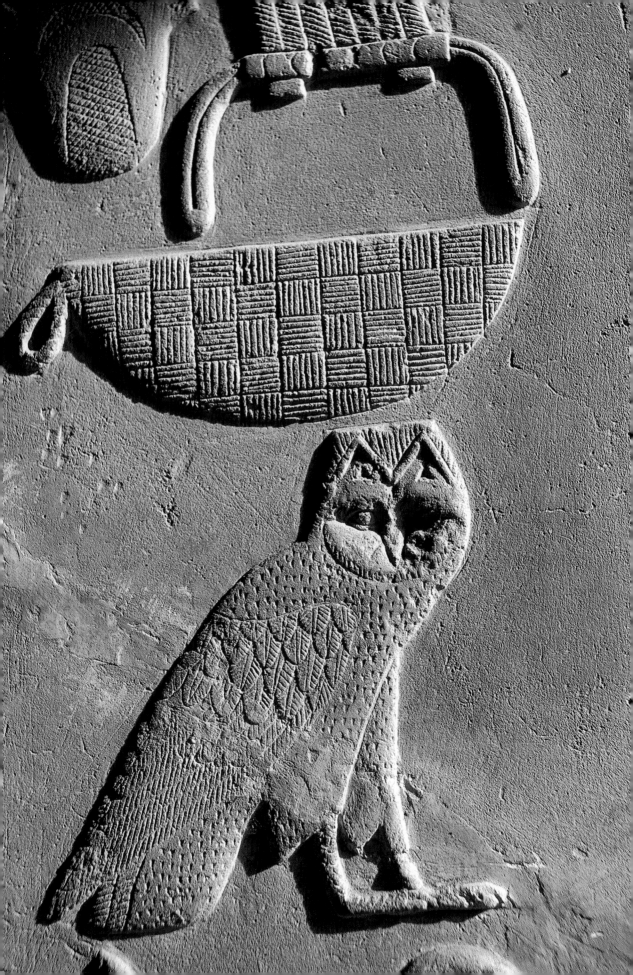

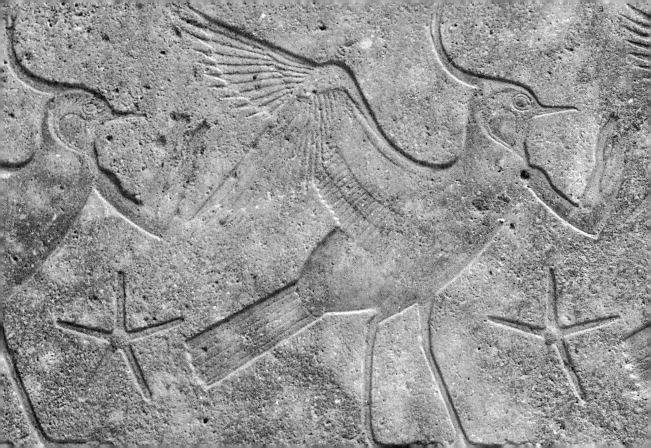

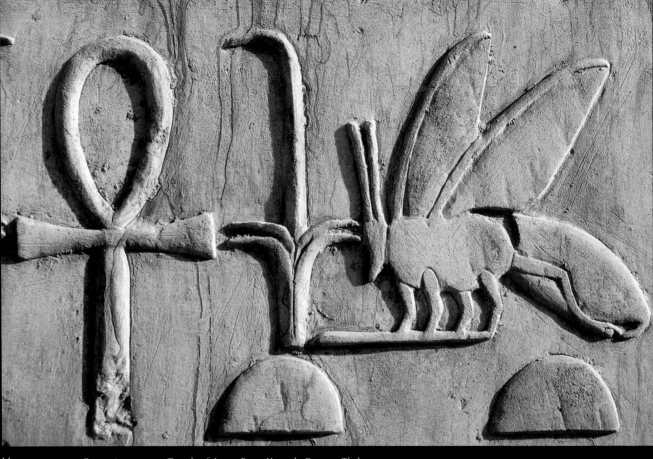

HIEROGLYPHICS. *Open-air museum. Temple of Amon Ra at Karnak. Eastern Thebes.*

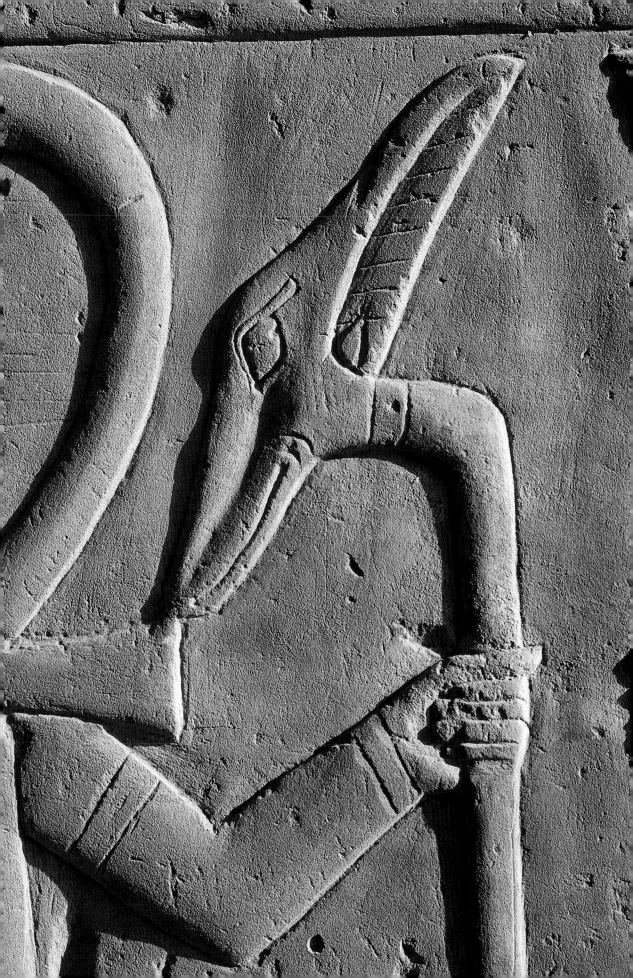

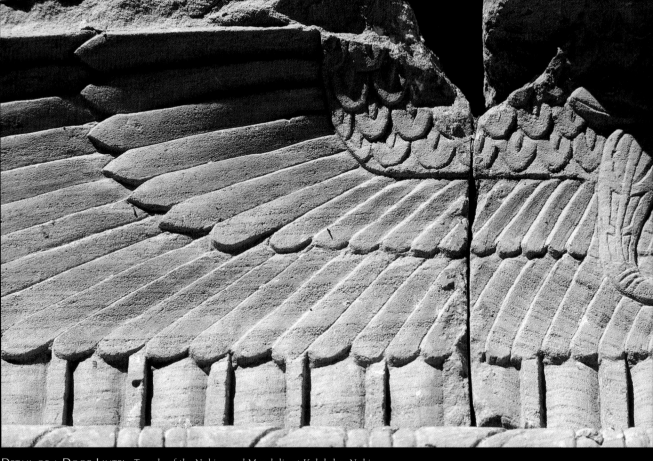

DETAIL OF A DOOR LINTEL. *Temple of the Nubian god Mandulis at Kalabsha. Nubia.*

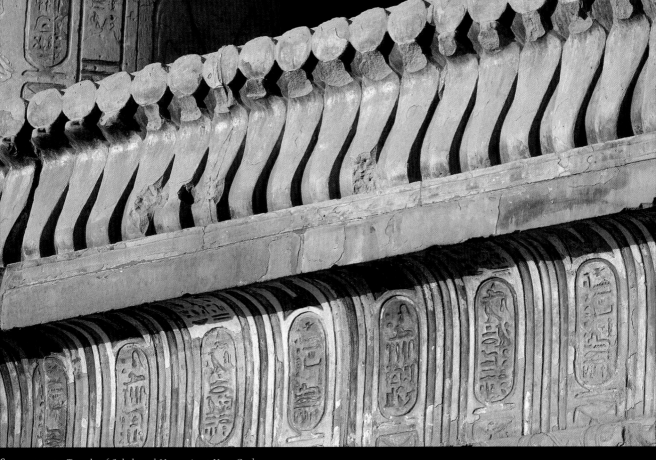

SCREENWALL. *Temple of Sobek and Haroeris at Kom Ombo.*

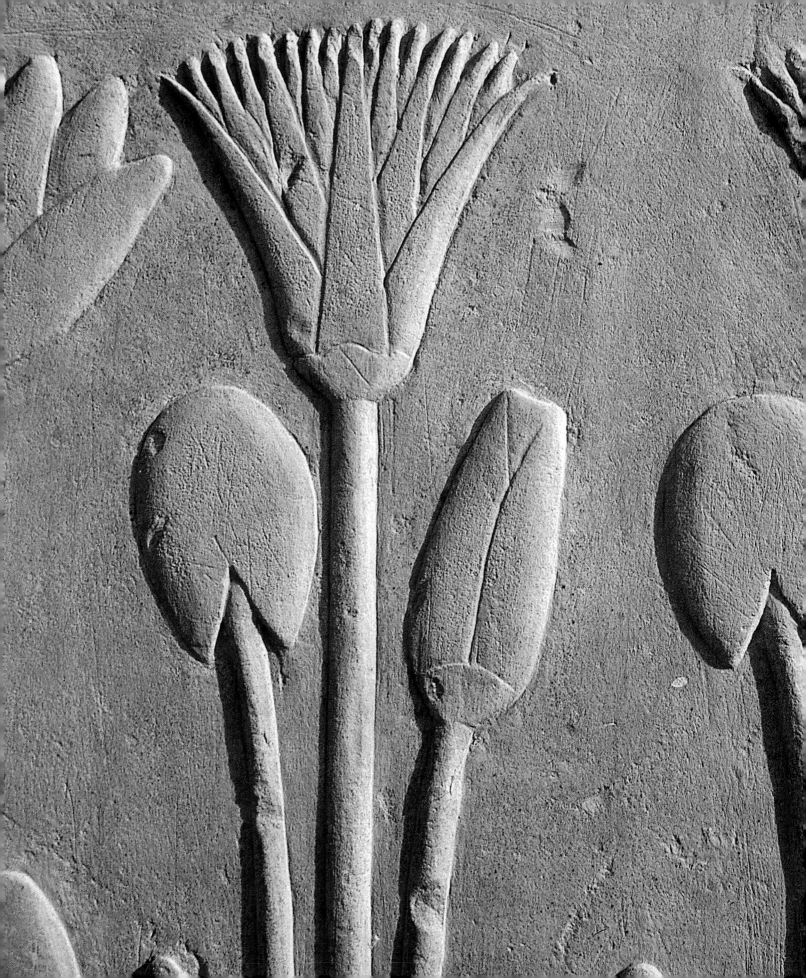

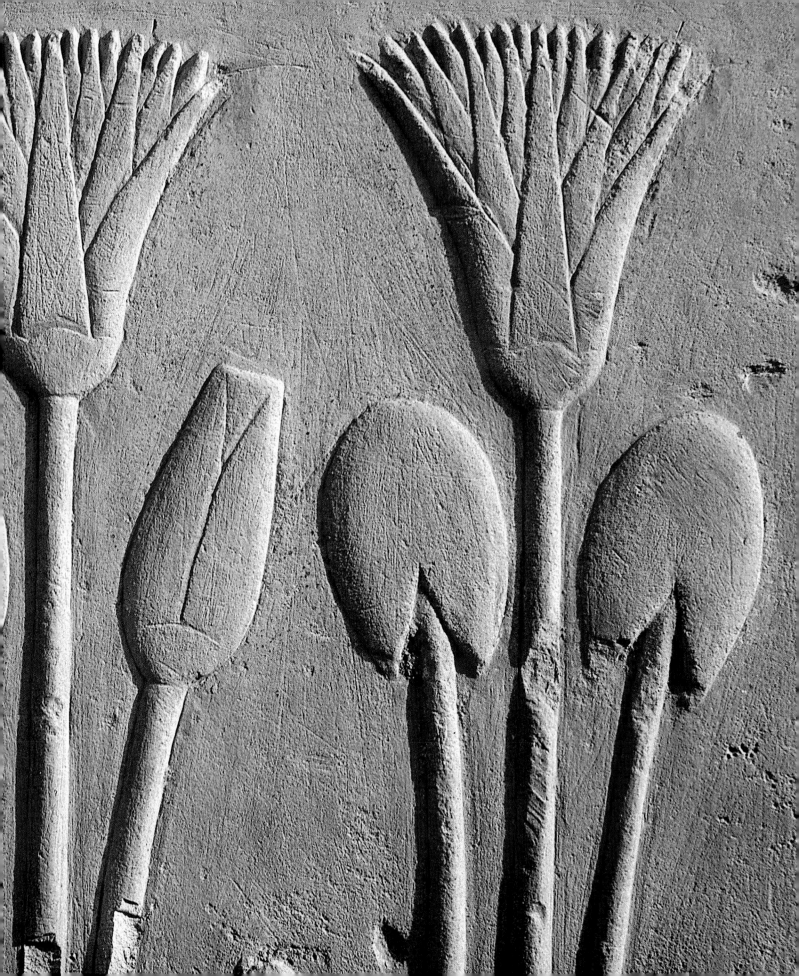

THE PLANT WORLD

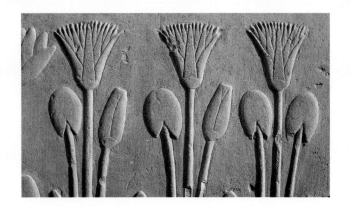

Venturing deeper and deeper into the hypostyle hall of the pharaonic temple, the visitor is struck profoundly by the sense of the place. Here is another world, out of scale and magical as a forest. The sense of wonder is made even more intense by the flight of birds in the heights, their chirping and rustling of wings.

Despite the abundance of the Nile waters, pharaonic Egyptians knew only a narrow range of flora. Trees were few, their shadows precious. Only three kinds of landscape are represented in the images that the ancient Egyptians have left behind.

A few rare hunting or desert battle scenes depict a sparse vegetation but one that is well adapted to the sand. Images of swamp flora, on the other hand, are very common. These mostly show papyrus thickets with their respective fauna and rare lotus flowers that embody a symbolism of primordial waters. Finally, in several representations, gardens are shown planted around rectangular pools. Their restrained borders are carefully aligned and growing with flowers and trees chosen according to their subtle symbolic allusions: poppy, cornflower, mandrake, vine, sycamore, or date palm. Most garden scenes appear in tomb paintings.

As was typical in later Greek mythology, many Egyptian divinities were associated with plant life. The sweet sycamore serves as a refuge for a wide variety of goddesses: Nut, Hathor, and even Isis. They had the power to transform themselves into a fountain and, through their divine intervention, to shower blessings on the dead. The name of Osiris is tied to viniculture and to wheat, both symbols of rebirth, and the lettuce of Min seems to have aphrodisiacal virtues. Even the pharaoh knelt before the *ished* tree, whose fruit bears his name.

Although native flora was limited, the Egyptians invented a number of decorative elements to embellish the holy establishments. They fashioned a world composed of stone vegetation and re-created in their temples a universe in which life could bloom. The cracked floors of the sanctuaries were frequently paved with rare stone such as alabaster and basalt, evoking Egypt's desiccated earth as it awaited the annual flood. The columns rise toward the ceiling the way trees reach for the sky. Although the date palm can be found depicted in temples, artists found their main inspiration in the plants of the swamps, the papyrus and the lotus. Papyrus and lotus decorated the reliefs at the bases of the walls. Motifs of reed screens or woven palms, the *khekeru*, protected the summits. In the Late Period, the Egyptians merged the formerly distinct palmlike, lotuslike, and papyriform capitals in a composite approach that harmoniously combined a mélange of different flowers and plants.

Originally, decoration was pure and rare. By the Late Period, however, the creative impulse had spawned an extravagant design. The exuberance and the quantity of flowers and leaves created completely baroque capitals. This new, ripe, blossoming décor expressed itself forcefully across all of Egypt, stretching its inspirations into abstractions, and finally, successfully spreading its ideas to the Mediterranean Christian world.

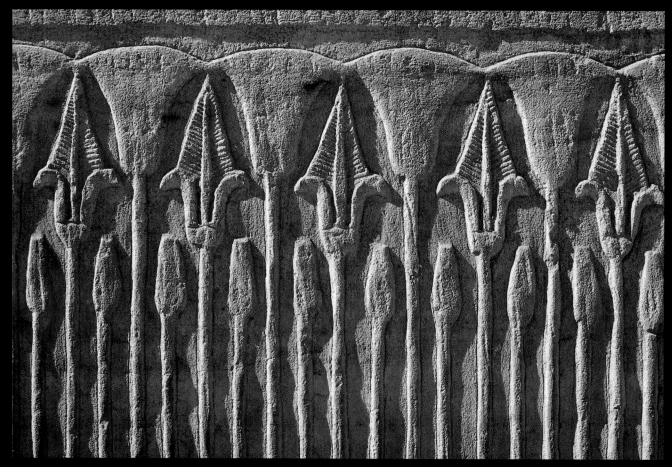

ALTERNATING LOTUS AND LILIES (?). *Temple of Sobek and Haroeris at Kom Ombo.*
OFFERING OF EARS OF WHEAT. *Temple of Sobek and Haroeris at Kom Ombo.* ▶

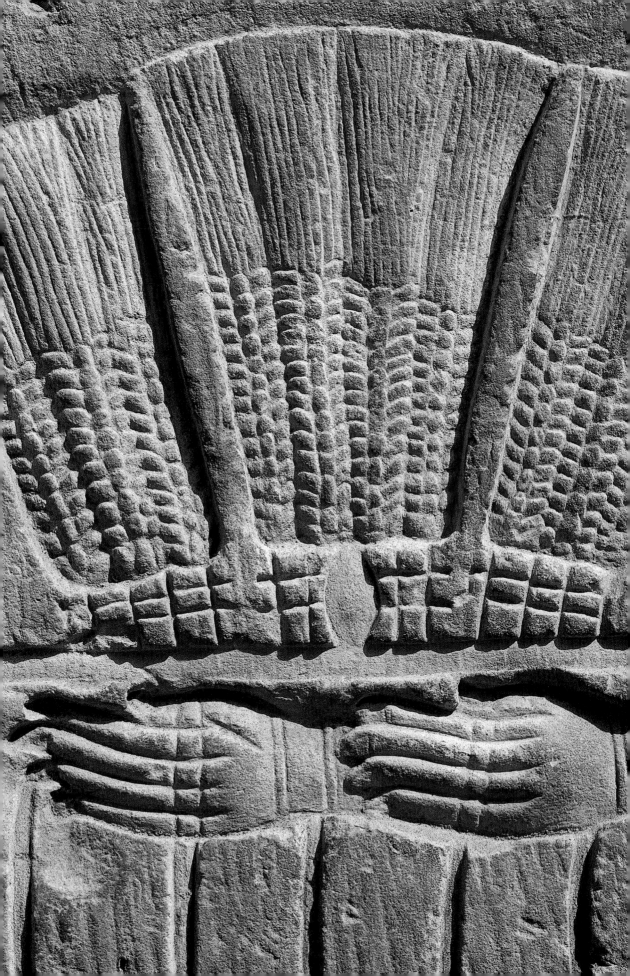

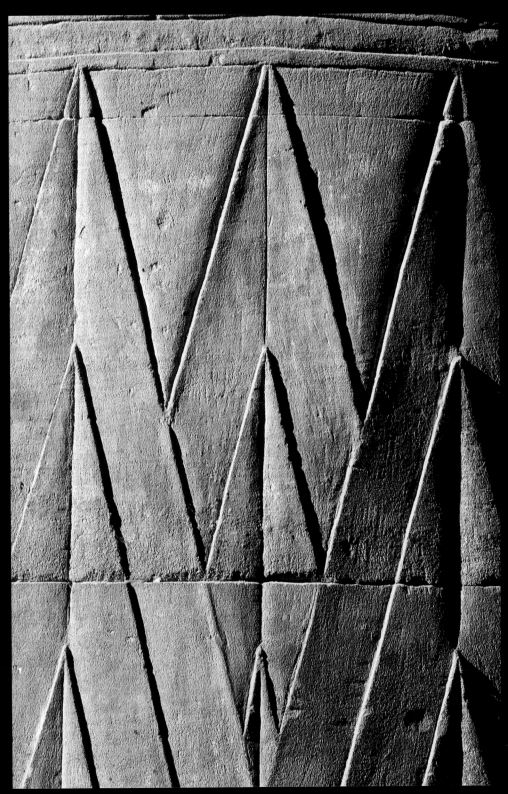

COLUMN BASE. *Temple of Horus at Edfu.*

◄ BASE OF A BUNDLE COLUMN. *Temple of Luxor. Eastern Thebes.*

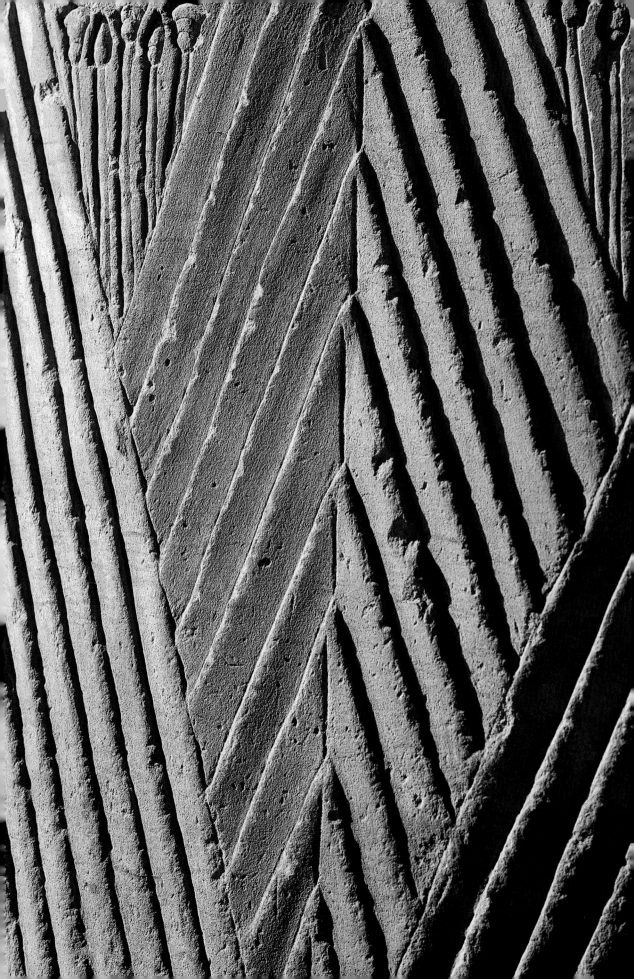

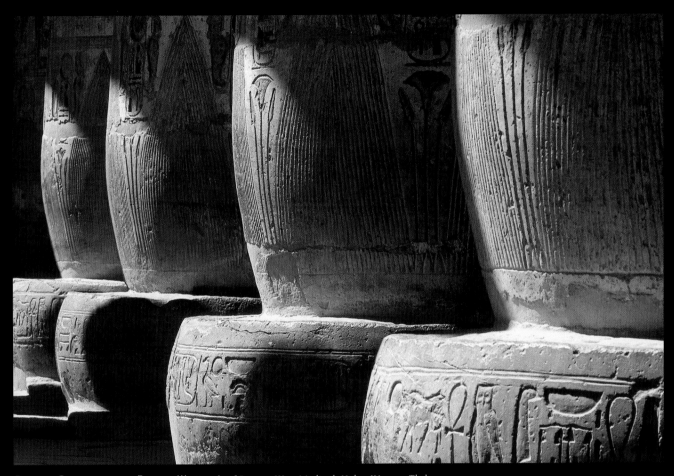

Base of Columns from Ramses III. *Temple of Ramses III at Madinah Habu. Western Thebes.*

◀ Column Base. *Temple of Sobek and Haroeris at Kom Ombo.*

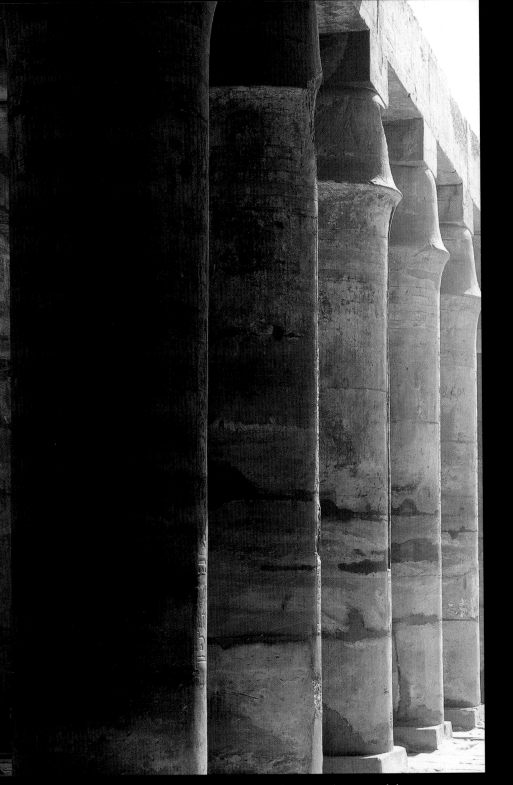

COLONNADE OF THUTMOSE III, *Akh menu. Temple of Amon Ra at Karnak. Eastern Thebes.*

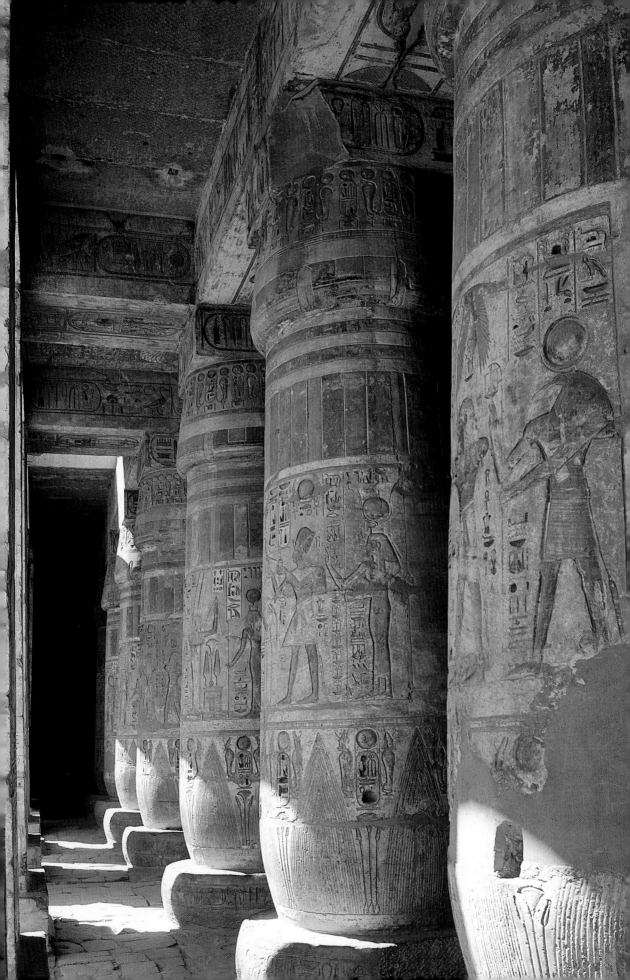

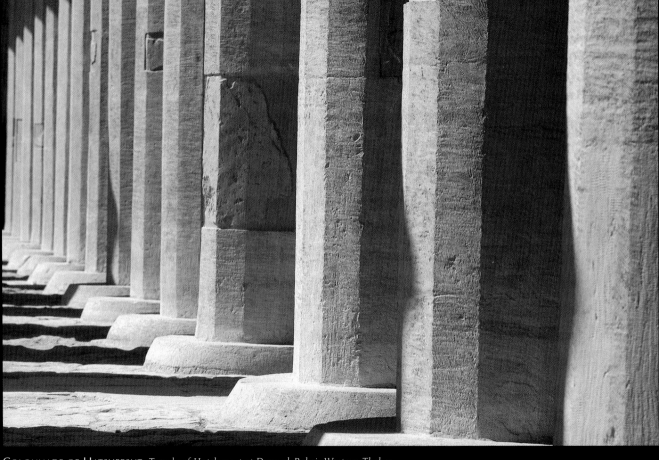

COLONNADE OF HATSHEPSUT. *Temple of Hatshepsut at Dayr al-Bahri. Western Thebes.*

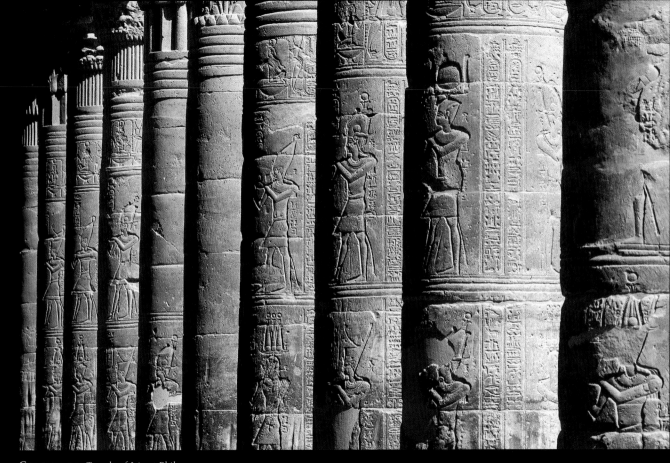

COLONNADE. *Temple of Isis at Philae.*

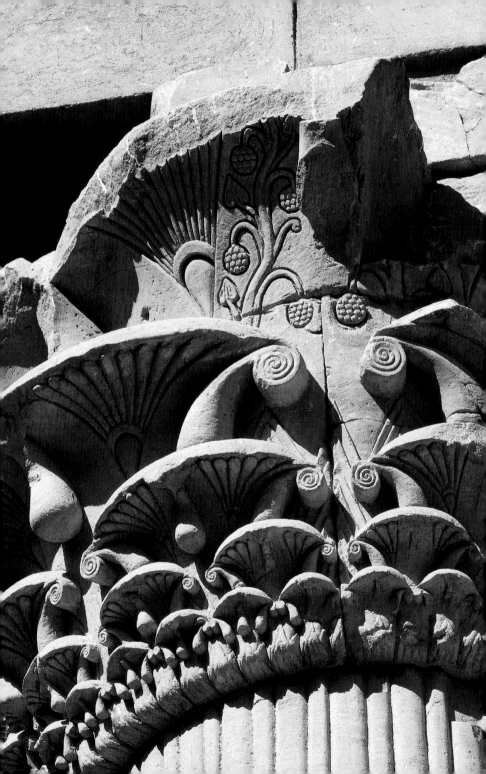

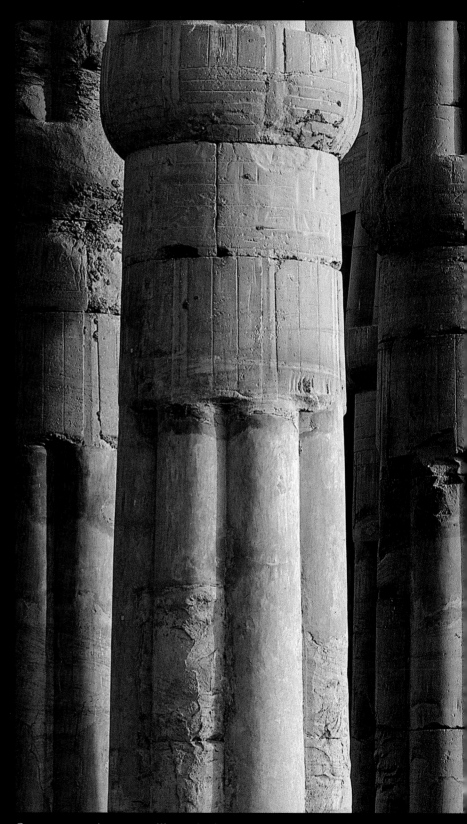

COLONNADE OF AMENHOTEP III. *Temple of Amon Ra at Luxor. Eastern Thebes.*

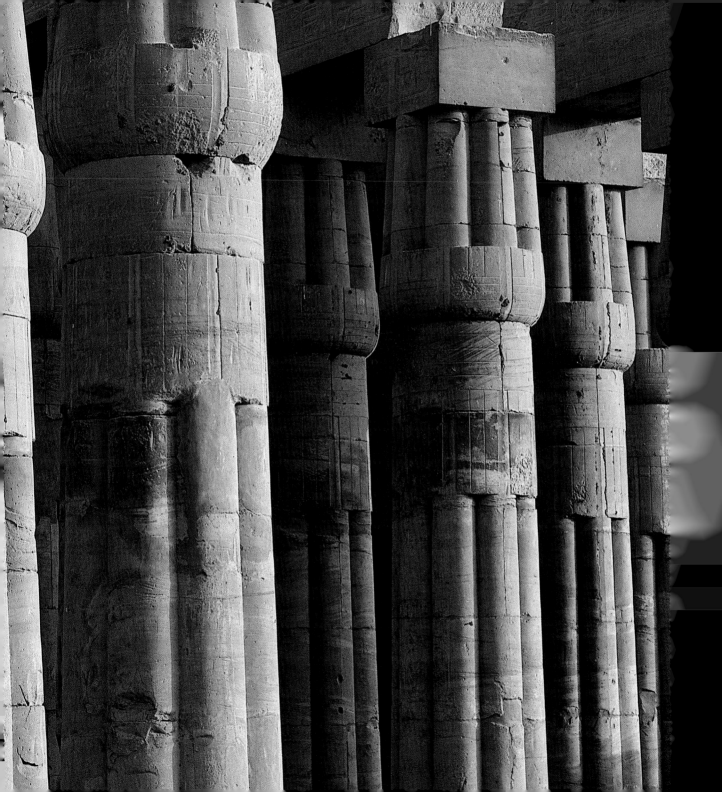

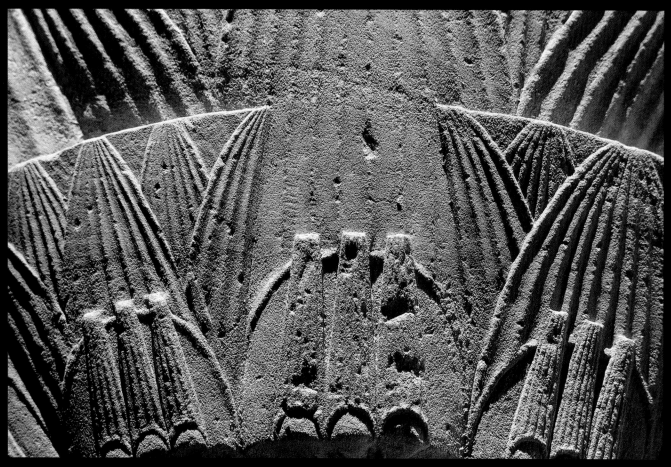

CAPITAL. *Colonnade of the pronaos to the Temple of Isis at Philae.*

CAPITAL. *Temple of Qertassi. Nubia.* ▶

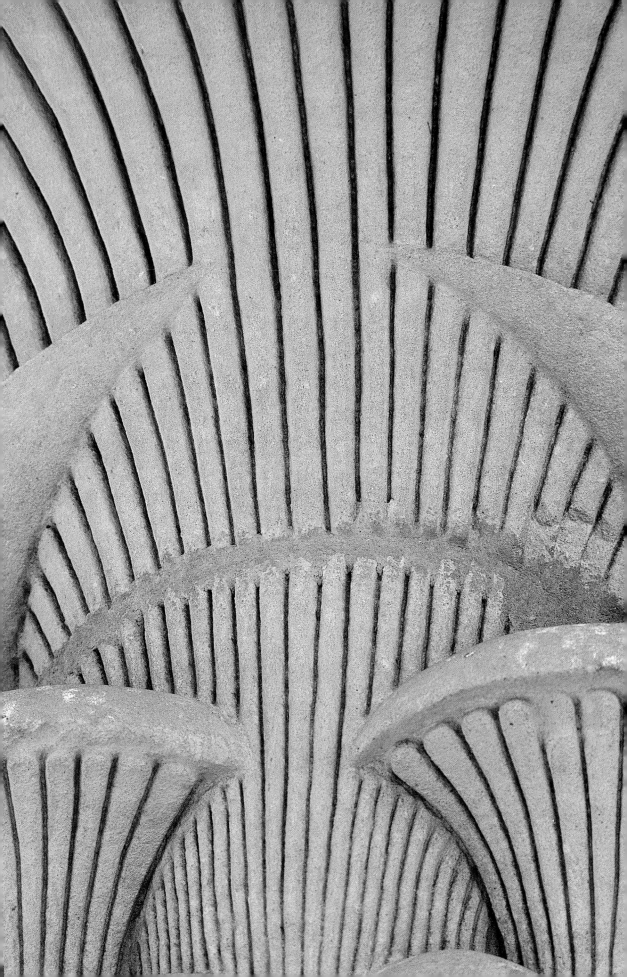

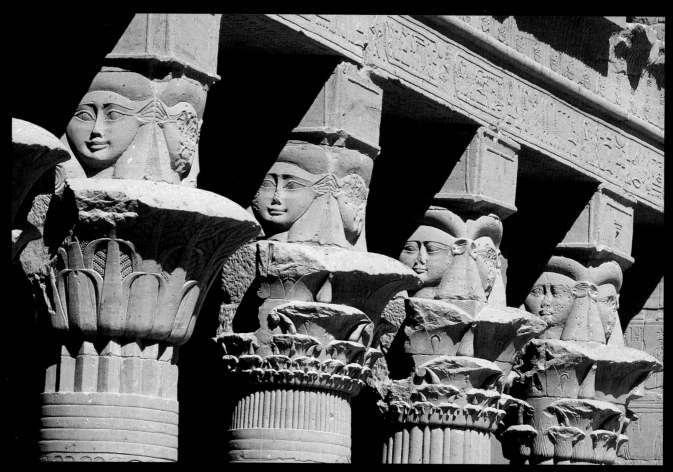

CAPITAL. *Colonnade of the Mammisi of the Temple of Isis at Philae.*

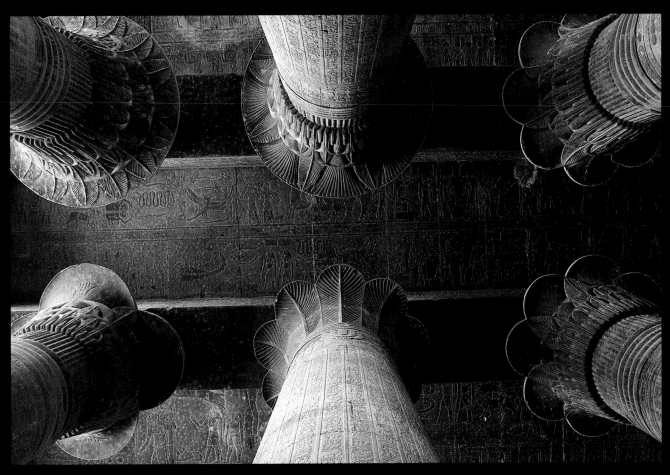

PRONAOS CEILING. Temple of Khnum at Esna.

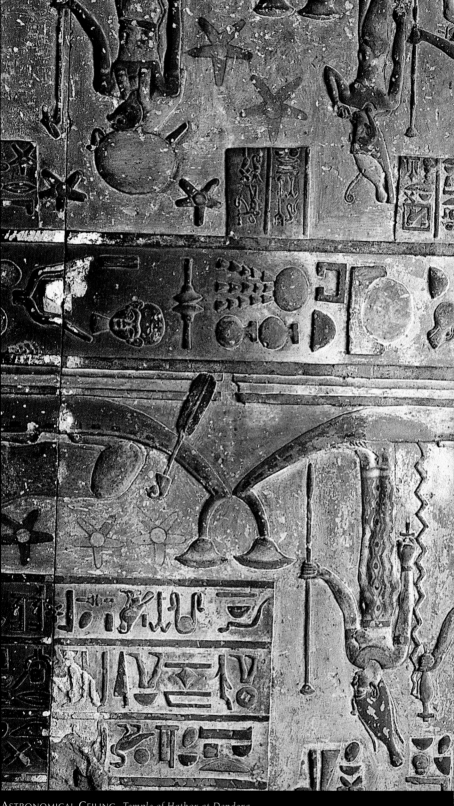

ASTRONOMICAL CEILING. *Temple of Hathor at Dendera.*

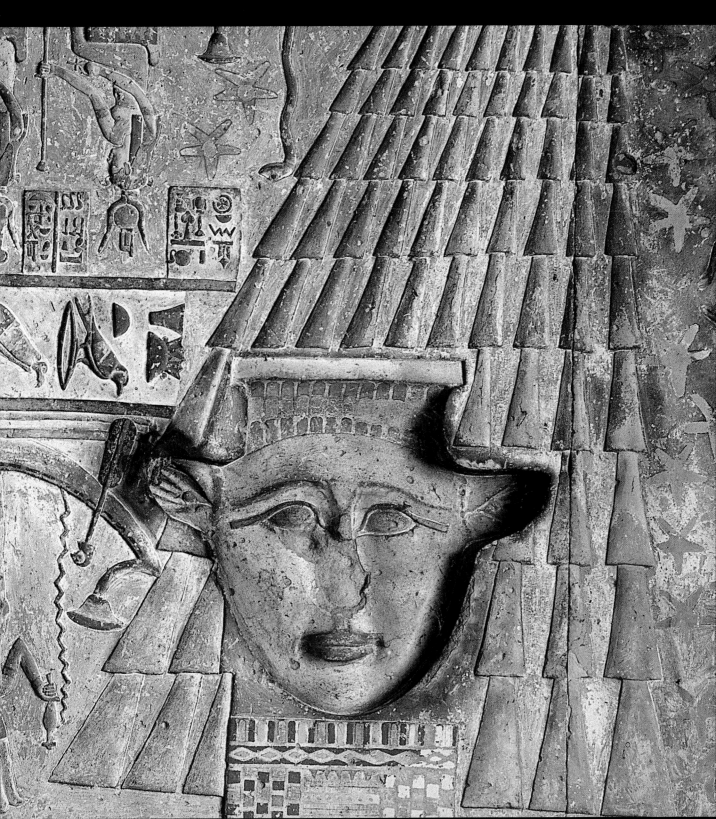

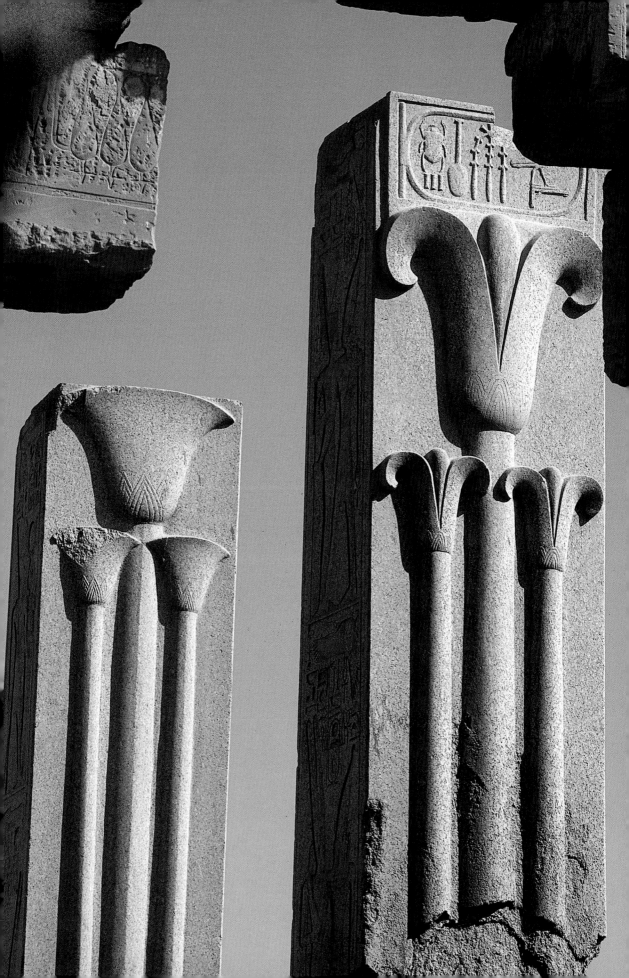

KHEKERU FRIEZE. Open-air museum. Temple of Amon Ra at Karnak. Eastern Thebes.

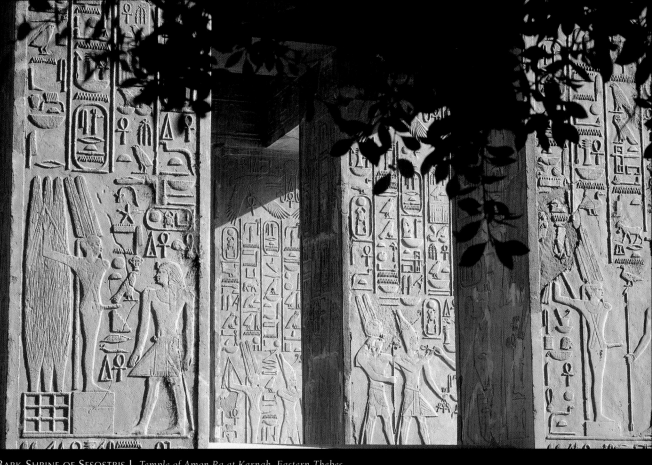

BARK-SHRINE OF SESOSTRIS I. *Temple of Amon Ra at Karnak. Eastern Thebes.*

SETI I UNDER THE *ISHED* TREE. *Temple of Amon Ra at Karnak. Eastern Thebes.* ▶

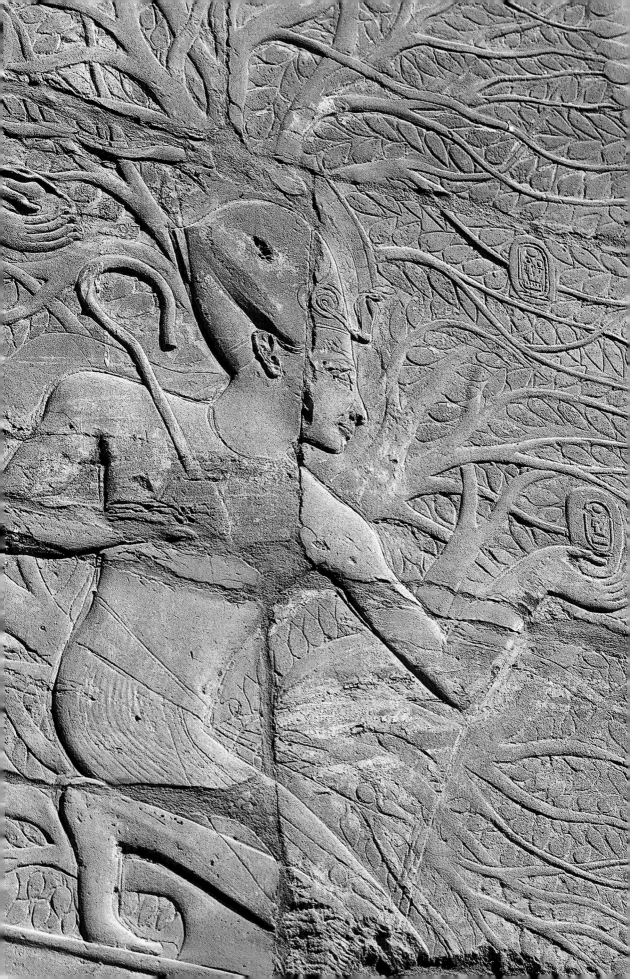

THE MINERAL WORLD

The magic of stone has always enthralled the human spirit. Whether a solitary stone or an assemblage of rocks, the fascination is the same. From the East to the West, from the pyramids of Giza to Stonehenge, stone seems to exude a mystery whose power transcends the ages.

Since the creation of the world, the Nile valley has been a mineral universe stretching from the cataracts of the south to the delta in the north, east from the Sinai Desert to the western oases.

Quarries of pink granite and gray diorite are found in the Aswan region. Alabaster and marble are located in Middle Egypt, around Minya. Sandstone comes principally from Nubia but also from Gebel el Silsila, slightly to the south of Luxor, and at Gebel Ahmar near Cairo. As for limestone, deposits run the full length of the river, and the eastern desert around the Red Sea is rich in basalt, diorite, graywacke, porphyry, and serpentine, among others.

Human beings took this natural mineral world and transfigured it to a scale commensurate with their gods. The extraordinary vestiges of their efforts still tower across the plains of the Nile.

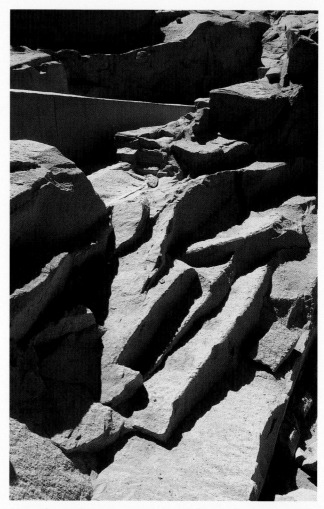

ASWAN: GRANITE QUARRY WITH AN UNFINISHED OBELISK. *The Egyptians probably rough-cut the blocks on site to avoid transporting defective material.*

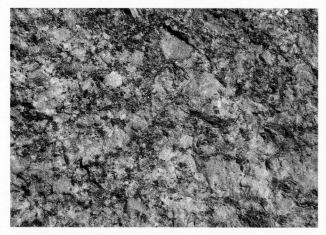

ASWAN: CLOSE-UP OF PINK GRANITE IN ITS RAW STATE. *Granite is an igneous rock primarily grained in light colors.*

MADINAT HABU: CLOSE-UP OF TEMPLE STATUE OF POLISHED PINK GRANITE.

WADI EL-SEBOUA: CLOSE-UP OF SANDSTONE ROCK. *The sandstone is a sedimentary detrital rock whose coloration runs primarily to shades of ocher.*

ABU SIMBEL: CLOSE-UP OF THE FAÇADE OF THE SMALL TEMPLE OF QUEEN NOFRETARI.

KARNAK: CLOSE-UP OF THE GRANITE BASE OF A BANNER. *Fifth pylon of the temple of Amon Ra.*

KARNAK: CLOSE-UP OF THE BARK-SHRINE OF HATSHEPSUT. *The use of silicified sandstone is quite unusual, and the rock is frequently confused with quartzite.*

KARNAK: CLOSE-UP OF THE BARK-SHRINE OF AMENHOTEP I. *Given its extreme fragility, alabaster was rarely used over large surfaces.*

KARNAK: CLOSE-UP OF A DIORITE STATUE OF SEKHMET. *Most of this divinity's statues were made from this material.*

ILLUSTRATIONS

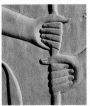

JACKET FRONT FLAP: TWO HANDS HOLDING A BATON. OPEN-AIR MUSEUM. TEMPLE OF AMON RA AT KARNAK. EASTERN THEBES.
These two hands that together hold a baton create a moving image. Rather than portraying a test of strength— as it might seem at first—the scene instead shows the act of a gift. In a magical gesture, the god, guardian of all powers, permits his royal son to hold his scepter and thus confers his temporal might. The sculpted limestone block presents all the characteristic elements of pharaonic art, but it also meets the criteria of universal art: spirituality, humanity, beauty. Ca. 2000 BC.

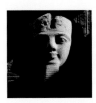

PAGE 4: RAMSES II.
TEMPLE OF LUXOR. EASTERN THEBES.
Particularly striking in the first court of the temple of Luxor is the face of this colossal statue of Ramses II, emerging from the penumbra of the southeast colonnade. Eleven granite statues adorn the temple courtyard. Although they were executed in the era of Amenhotep II, Ramses II claimed them for himself by modifying their faces and by adding cartouches engraved with his name (see page 20). Eighteenth to Nineteenth Dynasties.

THE DIVINE AND HUMAN WORLD

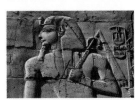

PAGES 6–7, 8: SETI I.
TEMPLE OF AMON RA AT KARNAK.
EASTERN THEBES.
Often modified in past eras, these mural sandstone reliefs are found at the northern tip of the west face of the hypostyle hall. This detail illustrates the scene where a goddess leads Seti I, father of the great Ramses, toward the god Amon Ra. The king is adorned with the *nemes* headdress, and his forehead is crowned with the *uraeus*. He wears the royal beard and holds the two scepters of royalty, the *heqa* and the *nekhekh* against his shoulder. The pentimenti of the successive artists are very clearly visible, and the intensification of certain features involuntarily provides a real depth to this magnificent relief. Nineteenth Dynasty.

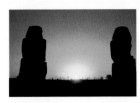

PAGE 10: THE COLOSSI OF MEMNON.
AMENOPHIUM. WESTERN THEBES.
The two colossi of Memnon, south and north, are the most visible vestiges of a monumental complex almost 2,000 feet (600 meters) long constructed by Amenhotep III. Carved from a solid block of silicified sandstone, these enormous figures each measure about 65 feet (20 meters) high. Damaged by an earthquake in 27 BC, the colossus on the left emitted sounds that ancient Greek visitors took to be the voice of the Ethiopian king Memnon, killed at Troy. They believed they were hearing him moaning a salutation to his mother, the goddess Aurora. The vibrations ceased during the statue's repair under Emperor Septimius Severus in the second century AD. Eighteenth Dynasty.

PAGE 11: NILE GOD.
AMENOPHIUM. WESTERN THEBES.
Detail of a relief found on the right side of the seat of the southern colossus of Memnon (see page 10). The thrones of Egyptian sovereigns commonly depict a scene showing the union of Upper and Lower Egypt, the *sema tawy*, symbolized by a knot formed of the stalks of lilies and papyrus held by the two Nile gods. The Nile god appears here according to convention, with an ample stomach, a pendulous teat, and wearing a belt and loincloth made of strips, like the river boatmen wear. Eighteenth Dynasty.

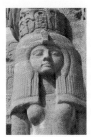

PAGE 12: NOFRETARI.
SPEOS (CUT ROCK) TEMPLE OF RAMSES II AT ABU SIMBEL, NUBIA.
Queen Nofretari was considered the favorite wife of Ramses II, "the beauty who belonged to him." The façade of the great temple of the royal consort presents her as if in the act of walking, with the length of her right leg from the northern colossal statue decorating the temple entry. She wears a *uraei* poised on her heavy wig. Several yards from his great temple, Ramses II constructed a small temple dedicated to the goddess Hathor of Ibchek, with whom Nofretari had become identified. Sandstone. Nineteenth Dynasty.

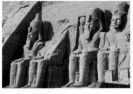

PAGE 13: *SPEOS* TEMPLE OF RAMSES II AT ABU SIMBEL, NUBIA.
This atypical temple, about 168 miles (280 kilometers) south of Aswan, was a sanctuary created from a sandstone mountain for Ramses II. Consecrated to the sun god Ra-Horakhty, the subject of the monument is actually Ramses II deified. Each day the dawn sets ablaze the eastern façade, carved in the form of the pylon along with four colossal statues representing Ramses II. The pylon measures 108 feet (33 meters) high, while the colossi only rise 66 feet (20 meters). Twice a year, at the summer and winter solstices, the sun penetrates deep into the sanctuary and illuminates the four sculptures of the divinities of the site: Ra-Horakhty, Amon, Ptah, and Ramses II. Nineteenth Dynasty.

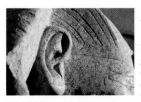

PAGE 14: AMENHOTEP II.
TEMPLE OF AMON RA AT KARNAK.
EASTERN THEBES.
Placed to the left of the fifth pylon, a pink granite statue represents Amenhotep II seated on a cube-shaped throne. This close-up reveals only one part of the royal profile and allows us to admire the realistic outline of the beautifully shaped ear and the showcasing of the pinna, the concha, and the lobe. The incisions defining the ritual stripes of the *nemes* headdress are also clearly visible. No trace of color remains. Eighteenth Dynasty.

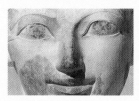

PAGE 15: HATSHEPSUT.
TEMPLE OF HATSHEPSUT AT DAYR AL-BAHRI.
WESTERN THEBES.
This fragmentary head in painted limestone shows us the radiant face of Hatshepsut, with her large wide-open eyes and the trace of a smile on her lips. She belongs to one of the colossal Osiride statues from the third terrace of the temple, a rare example in Egyptian history of a female pharaoh represented under the aspect of Osiris, judge of the dead. The only one of its kind, the temple is formed of three terraces that seem to launch an attack on the limestone cliffs. Eighteenth Dynasty.

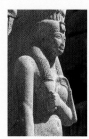

PAGE 16: BENTANAT.
TEMPLE OF AMON RA AT KARNAK. EASTERN THEBES.
Situated in the first courtyard of the temple of Amon Ra, this figure of the queen is found backed against a colossal granite statue of Ramses II (with a height of 49 feet, or 15 meters). The statue was first usurped by Ramses VI, then by Pinedjem. The queen is probably Bentanat, daughter of Ramses II, whom he married after the death of Nofretari. Crowned with the *uraeus*, which is topped by two tall plumes and decorated in front with two erect cobras, she holds in her left hand a scepter formed of a flower whose long stem bends toward the ground. Nineteenth to Twenty-first Dynasties.

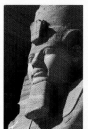

PAGE 17: RAMSES II.
SPEOS TEMPLE AT ABU SIMBEL, NUBIA.
The four seated colossi of Ramses II stand guard in front of the temple's façade. The temple itself was dug deep into the mountain. Here the king wears the *pschent* double crown over the *nemes* headdress, as well as the horizontally striped false beard. As photogrammetric analysis reveals, the thickset appearance of the faces and bodies. This deliberate artistic choice confirms the pharaonic sculptors' knowledge of perspective. Sandstone. Nineteenth Dynasty.

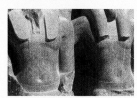

PAGE 18: RAMSES III AND THE GOD THOTH.
TEMPLE OF RAMSES III AT MADINAT HABU.
WESTERN THEBES.
On the left of the temple's hypostyle hall sit a pair of statues with a conventional appearance. Although badly damaged, the sculptures represent Ramses III (left) and Thoth, god of wisdom and scribes (right). The bottom edges of the royal *nemes* and the heavy feminine wig worn by the god are still visible. Acting as the counterpart to the couple, another pair shows the king seated beside Maat, goddess of balance and justice. The figures are carved of granite, with plinths of sandstone. It is truly rare to find these dyads in situ in the temple. Twentieth Dynasty.

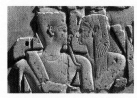

PAGE 19: AMON AND MUT.
TEMPLE OF AMON RA AT KARNAK.
EASTERN THEBES.
This scene full of tenderness comes from the wall of the third pylon: here the god Amon is embraced by his wife, the goddess Mut. The faces are delicate and realistic, but the arms of the goddess are intentionally elongated so she can join her hands behind Amon to form a protective circle around him. Her headdress is formed of a vertically sectioned wig partially covered by the finely engraved wings of a vulture, while the headdress, beard, and neckpiece of the god are apparently not finished. Sandstone. Nineteenth Dynasty.

PAGE 20: RAMSES II.
TEMPLE OF LUXOR. EASTERN THEBES.
In the first court of the temple of Luxor, between the seventy-four monostyle sandstone columns, towers one of eleven colossi (see page 4). This granite statue was originally made in the image of Amenhotep II but was later modified under Ramses II. When the light slips into the enclosure, the slender ray emphasizes the verticality of the column, the royal profile, and the horizontally striated beard. Nineteenth Dynasty.

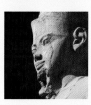

PAGE 21: AMON.
TEMPLE OF AMON RA AT KARNAK. EASTERN THEBES.
This limestone statue of the god Amon sits in the great hypostyle hall of the temple. It is attributed to the time of Tutankhamen, whose portrait we recognize here. As a model for the face of the gods of Egypt, the sculptors chose that of the reigning king. With its almond eyes, brows indicated by a slight bulge, and full smiling lips, all the young monarch's characteristic adolescent features are clearly identifiable in this statue. Eighteenth Dynasty.

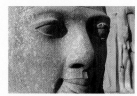

PAGE 22: RAMSES II.
TEMPLE OF LUXOR. EASTERN THEBES.
The magnificent granite face of the pharaoh wearing the *nemes* is today situated on the ground in front of the first pylon of Luxor. In the background, the small, almost life-sized, figure of a standing princess only serves to accentuate the colossal aspect of this royal visage. The heavy-lidded eyes look down; the strong nose is accentuated by the curved depression of the philtrum; and the corners of the king's mouth trace a smile. But is this a real portrait of Ramses II or a supplanted image? The fact that other statues of this temple bear his cartouche does not provide enough of a confirmation. Granite (see page 4). Nineteenth Dynasty.

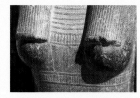

PAGE 23: SEKHMET.
TEMPLE OF RAMSES III AT MADINAT HABU.
WESTERN THEBES.
Sekhmet, beloved of the sun god Ra, can be represented under multiple guises. This statue, carved in diorite, shows the goddess with the head of a lioness and a particularly feminine torso. Two sections of a tripartite wig conceal the top of her firm and rounded bosom, just covered by a linen tunic held up with barely visible straps. The only ornamentation on the clothing is the passementerie ribbon visible under the breasts (see pages 26, 76, and 77). Eighteenth Dynasty.

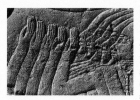

PAGES 24–25: NORTHERN PRISONERS.
PYLON FROM THE SMALL TEMPLE OF MADINAT HABU. WESTERN THEBES.
These well-depicted prisoners from the Near East, with their short beards, aquiline noses, and slightly almond-shaped eyes, are located on the western face of the pylon's southern section. It shows the prisoners with heads pulled back—King Taharqa holds them tightly by the hair—and arms raised in submission. Part of the heroic representations consecrated by the pharaoh to the god, this panel portrays Egypt's hereditary enemies: Middle Easterners and Africans. Twenty-fifth Dynasty.

PAGE 26: ROW OF SEKHMETS.
OPEN-AIR MUSEUM. TEMPLE OF AMON RA AT KARNAK.
EASTERN THEBES.
The temple of Mut, the goddess wife of Amon, is found not far from the temple of Amon Ra at Karnak. This original construction was, for the most part, the work of Amenhotep III; it housed a large number of goddesses with the bodies of women and the heads of lionesses. Today, some of these diorite statues have been regrouped in the outdoor museum of the temple of Amon. This unusual photograph emphasizes the play of curves and straight lines. The roundness of the shoulders and the breasts contrast with the verticality of the well-modeled cylindrical arms and the precisely striated wigs (see pages 76 and 77). Eighteenth Dynasty.

PAGE 27: RAMSES III.
TEMPLE OF AMON RA AT KARNAK. EASTERN THEBES.
In the first court of the temple of Amon Ra at Karnak is a Bark temple of Ramses III, with a pylon, enclosure, hypostyle hall, and sanctuary. Sixteen granite Osiride colossi tower on either side of the courtyard. Under the mummiform sheath of Osiris, the slender legs with their subtly modeled knees are apparent. Twentieth Dynasty.

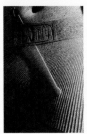

PAGE 28: RAMSES II.
TEMPLE OF LUXOR. EASTERN THEBES.
Detail of a pink granite colossus constructed under Ramses II, which stands in the court of the temple of Luxor. The monarch's traditional kilt, the *shendjit*, is carved with an extremely realistic pleated pinwheel design. The fullness of the haunches under the fabric is perceptible, and a beautifully shaped navel hollows out a slightly rounded stomach. The king carries a sleek dagger under a belt whose buckle is decorated with a cartouche engraved with the royal name: "Ramses, Beloved of Amon" (see pages 4 and 20). Eighteenth to Nineteenth Dynasties.

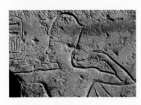

PAGE 29: RAMSES II.
SPEOS TEMPLE OF BEIT EL-WALI, NUBIA.
Carved in sandstone, this figure of the king aiming a bow and wearing a *khepresh* headdress is full of movement and vigor. Some of the temples of Nubia are decorated with works that tend to lack the brilliance of those created in the great religious city centers like Thebes or Memphis. Although more unsophisticated, the art is sometimes more enjoyable. This temple dedicated to Amon Ra, was, like several others, taken down and then reconstructed on a site closer to Aswan during the 1965 Nubian campaign. Nineteenth Dynasty.

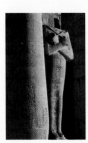

PAGE 30: RAMSES II.
RAMESEUM. WESTERN THEBES.
In the second court of this temple rise these colossal statues, called Osirides, which represent Ramses II. Like Osiris, god of the dead, the royal bodies are sheathed in a shroud. Here, as in all temples of "millions of years" generally constructed during a sovereign's life, a special cult dedicated to the memory of the deceased king was celebrated. Although badly deteriorated, this sandstone structure with its granite statues was celebrated by Romantic poets such as Shelley. It is currently undergoing restoration. Nineteenth Dynasty.

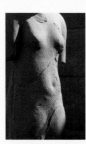

PAGE 31: AMONIT.
TEMPLE OF AMON RA AT KARNAK. EASTERN THEBES.
Situated in front of the sixth pylon and acting as counterparts to each other are two statues of Amon and Amonit. Erected in sandstone, they each measured almost 20 feet (6 meters) in height before they were broken. The statue of Amonit is particularly moving, the sculptor having marvelously rendered the body, with its rounded and sensual forms, and given an individual elegance to the hollow of the navel and the curve of the hip. The suppleness of the art breaks with the hieratic appearance of certain eras and testifies to the continuing influence of the Amarna style. Executed in the time of Tutankhamen, the statues were later usurped over by Horemheb. Eighteenth Dynasty.

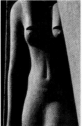

PAGE 32: PRINCESS.
TEMPLE OF LUXOR. EASTERN THEBES.
With its modern appearance, this feminine figure of great feeling demonstrates the sensitive powers of observation sculptors had in the time of the pharaohs. Carved from granite, the young body of the princess is a skillful and harmonious sequence of curves and contours. The statue is located to the right of the temple entry before the first pylon and, like the Nofretari at Abu Simbel, rubs shoulders with a seated colossus (see page 12). Eighteenth to Nineteenth Dynasties.

PAGE 33: NOFRETARI (?).
TEMPLE OF LUXOR. EASTERN THEBES.
Here, in a quite different style, is another other female figure with a more fragile appearance. Her delicate face is framed by a heavy wig with two parallel tresses. The statue could be attributed to a royal personage, as suggested by the sculpted *uraeus* that dominates her forehead. It could be Nofretari—an inscription situated near the left elbow bears her name—but it could also be the wife or one of the daughters of Amenhotep II, to whom the series of colossi in the first court of the temple of Luxor were dedicated. Granite. Eighteenth to Nineteenth Dynasties.

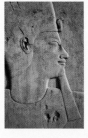

PAGE 34: SESOSTRIS I.
OPEN-AIR MUSEUM. TEMPLE OF AMON RA AT KARNAK.
EASTERN THEBES.
Carved in limestone—an extremely fragile material—this royal profile betrays an almost unreal beauty. With his haughty air, the sovereign wears the royal beard drawn in a flattened style as well as the white crown of Upper Egypt enhanced by a protective *uraeus*. At the base of his neck, a simple, perfectly rounded line is the beginnings of a necklace whose decoration is incomplete. Also important to note is the extreme finesse of the shape of the mouth and ear as well as the flawless modeling of the neck. Twelfth Dynasty.

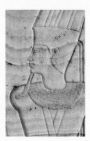

PAGE 35: ITHYPHALLIC AMON.
TEMPLE OF AMON RA AT KARNAK. EASTERN THEBES.
Detail of a relief of the chapel of Amenhotep I, sculpted in very fragile crystalline-veined alabaster. Amon wears a sacred plaited beard. His head is covered by a mortar-shaped headdress topped by two tall plumes with undefined vanes. The type of crossed ribbon visible under his *wesekh* collar indicates that Amon here plays the role of a fertility god (see page 53). Eighteenth Dynasty.

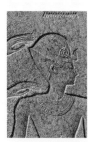

PAGE 36: HATSHEPSUT.
TEMPLE OF AMON RA AT KARNAK. EASTERN THEBES.
Relief embellishing a pink granite pyramidion located near the sacred lake of the temple of Amon Ra. This portrait is one of the most beautiful of Queen Hatshepsut, who kneels under the protective hands of Amon Ra with their tapering fingers. Her head is covered with a heavy *khepresh* helmet generally attributed to the male royalty of Egypt, and her *wesekh* collar is finely engraved. Eighteenth Dynasty.

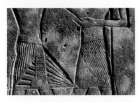

PAGE 37: HATSHEPSUT AND AMON.
BARK-SHRINE OF HATSHEPSUT. TEMPLE OF AMON RA AT KARNAK. EASTERN THEBES.
The next three images show photographic details of the same relief found in a Bark-Shrine built during the reign of Hatshepsut. The walls, made of silicified sandstone blocks, are covered with scenes that show different stages of the queen's life, like ritual journeys and ceremonial hunts. This first work shows Hatshepsut (left) from the waist down, before Amon. The queen wears a skirt with a flattened-out triangular front panel, and the god a simple kilt and a mortar crown indicated only by its long dorsal stalk (see pages 38 and 39). Eighteenth Dynasty.

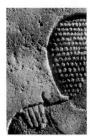

PAGE 38: HATSHEPSUT.
BARK-SHRINE OF HATSHEPSUT. TEMPLE OF AMON RA AT KARNAK. EASTERN THEBES.
This second photographic detail from the relief (see pages 37 and 39) offers a glimpse of Queen Hatshepsut's short wig with its strongly defined curls and the suggestion of a large necklace. The hand of the god Amon rests tenderly on her shoulder. Eighteenth Dynasty.

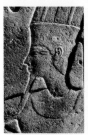

PAGE 39: AMON.
BARK-SHRINE OF HATSHEPSUT. TEMPLE OF AMON RA AT KARNAK. EASTERN THEBES.
The third photographic detail (see pages 37 and 38) shows the delicate profile of Amon. The eye is strongly defined by a line of kohl makeup and, like the preceding image, the necklace is outlined but unfilled. The sensitive workmanship exhibited in the hollows and the planes creates the play of shadow and light that the pharaonic artisans mastered so well. Eighteenth Dynasty.

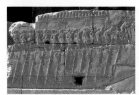

PAGES 40–41: ROWERS.
TEMPLE OF AMON RA AT KARNAK. EASTERN THEBES.
This badly deteriorated sandstone relief presents a partial view of the royal vessel of Amenhotep III. During religious festivals, it was used on the Nile to tow the famous barque *Ouserhet*, which contained the statue of the cult of Amon. The convoy also included the barks of the gods Mut and Khonsu. The number of sailors pulling on the excessively long oars gives a sense of scale to this ship, whose real length was about 131 feet (40 meters). Eighteenth Dynasty.

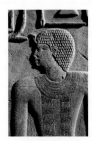

PAGE 42: STANDING KING.
OPEN-AIR MUSEUM. TEMPLE OF AMON RA AT KARNAK. EASTERN THEBES.
The king wears a short wig adorned with a cobra, one of the insignia of royalty. At his neck, a large necklace rests on a skillfully wrought sort of beaded stole. The shadow that outlines the silhouette of the king emphasizes the high relief of this work and accentuates the design. Traces of polychromy still remain on this isolated block of limestone.

PAGE 43: DETAIL OF THE TOMB OF KHAEMHAT.
TOMB NUMBER 57. NECROPOLIS OF SHEIKH ABD EL-GOURNAH. WESTERN THEBES.
The tombs hollowed out of the hills of Sheikh Abd el-Gournah were formed of an extremely delicate limestone. This close-up lets us appreciate the formal and geometric elegance of the Egyptian reliefs. The vertical tracks of the wig's long tresses contrast with the small repeating pattern created by the slanted ringlets. The carving of the *shebyu* and *wesekh* necklaces, of which only a small part is visible here, continue the roundness created by the shape of the head. With their balance of straight lines and contours, most relief scenes can be analyzed in this fashion. Eighteenth Dynasty.

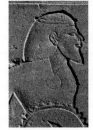

PAGE 44: NORTHERN PRISONER.
TEMPLE OF AMON RA AT KARNAK. EASTERN THEBES.
Carved in sandstone, this bust of an Asian prisoner wearing a pendant around his neck proves the sculptor's great powers of perception in terms of ethnic observation. The beginning of a large crenellated oval, evoking an unfinished citadel, is visible at the bottom of the image. The panel generally includes the inscription of the name—here we see only a mark—of a Near Eastern city or region conquered by the pharaoh. Situated to the west of the north obelisk between the fourth and fifth pylons, this relief dates from the era of Amenhotep II. Eighteenth Dynasty.

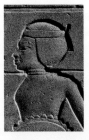

PAGE 45: SOUTHERN PRISONER.
TEMPLE OF AMON RA AT KARNAK. EASTERN THEBES.
This profile of an African prisoner with a rope around his neck is carved in sandstone. The same oval found in the panel of the Asian prisoner (see page 44) is also at the base of this image, but instead it contains the name of the city or region in Africa. Dating from the era of Amenhotep II, the relief is located to the west of the south obelisk, between the fourth and fifth pylons. Eighteenth Dynasty.

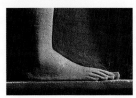

PAGE 46: FOOT.
TEMPLE OF SOBEK AND HAROERIS AT KOM OMBO.
A detail from a mural relief in the temple's south court, this profile of a foot gives the impression of being sculpted in the round. By its elongation and its elegance, its appearance contrasts with the characteristic figures of that era, whose bodies were weighed down by fat. The temple is entirely constructed of sandstone. Greco-Roman Period.

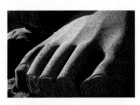

PAGE 47: ROYAL FOOT.
RAMESEUM. WESTERN THEBES.
This foot, a vestige of a colossal granite statue of
Ramses II, measures about 5 feet in length (1.5
meters). The damage at the tips of the toes still
allows a glimpse of the nails' lunules, and the
prominent metatarsus brings great vigor to the
anatomical reality of this work. Nineteenth
Dynasty.

PAGE 48: GOD AND THE KING.
TEMPLE OF AMADA, NUBIA.
This little temple of Amada, constructed under
Thutmose III, Amenhotep II, and Thutmose IV,
is dedicated to the solar gods Amon Ra and Ra
Horakhty. Its beautiful reliefs, engraved in
sandstone, still maintain their polychromy.
The intertwined legs shown here are those of a
king meeting a masculine divinity. The bottom of the short kilt is visible, and the
coloration is of red ocher. The instep of the foot is elegant and the heel bone well
drawn. Eighteenth Dynasty.

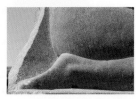

PAGE 49: A ROW OF FEET WITH HANDS AND BACK.
TEMPLE OF AMON RA AT KARNAK. EASTERN THEBES.
The overlapping pattern of feet, hands, and backs forms an
unusual, almost abstract, design. It forms part of the scene
in which the monarch Thutmose III holds Near Eastern
prisoners at his mercy (see pages 24–25). Treated here for
the first time on a gigantic scale, this theme is displayed on a
sandstone wall on the south face of the seventh pylon.
Eighteenth Dynasty.

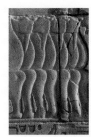

PAGE 50: STATUE OF A HIGH DIGNITARY.
TEMPLE OF AMON RA AT KARNAK.
EASTERN THEBES.
This statue is interesting because it presents
a figure hunkered on his heels in an
unconventional way. Striking, too, is the
simultaneously sensitive and realistic manner
in which the artist shaped the sturdy ankle,
the prominent external malleolus, and the bulging calf out of a block of raw
sandstone. The contour of the rounded buttocks may bring a woman to mind, but,
in reality, the statue is of "a royal administrator, possibly one of the last incumbent
monarchs from the end of the Middle Kingdom." Thirteenth Dynasty.

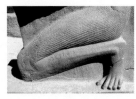

PAGE 51: KNEELING SETI II.
TEMPLE OF AMON RA AT KARNAK.
EASTERN THEBES.
A little larger than life size, this statue was
carved from sandstone and placed in the
hypostyle hall. Even without a head, it is a
remarkable piece of art. The spacing of the toes
provides solid footing for the position of the
pharaoh. The thigh muscle is alive under a pleated kilt, and the subtle nervous
tension in the calf is full of truth. Nineteenth Dynasty.

PAGE 52: AMON.
OPEN-AIR MUSEUM. TEMPLE OF AMON RA AT KARNAK.
EASTERN THEBES.
Several stone blocks originating from dismantled structures
are found in the open-air museum at Karnak. Among them is
this torso of the god Amon dating from the time of Thutmose
IV. The god wears a close-fitting bustier with straps, elegantly
decorated with a motif of small feathers, and the squared
neckline is partially edged with a braid of a geometric design.
The softness of the limestone accentuates the refined aspect
of the work. Chapel of Thutmose IV. Eighteenth Dynasty.

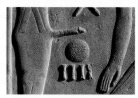

PAGE 53: ITHYPHALLIC AMON RA.
OPEN-AIR MUSEUM. TEMPLE OF AMON RA
AT KARNAK. EASTERN THEBES.
Amon Ra, the great god of Karnak, is here
represented in his role as a fertility god. At
left we see his body draped in a shroud. Above
his erect member are two points of a star,
signifying worship (see page 95), and below
are the solar disk and four vertical shafts. On the right, the pharaoh's arm is
adorned with a bracelet, and the edge of his skirt is visible. Twelfth Dynasty.

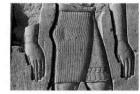

PAGE 54: PHARAOH WALKING.
TEMPLE OF SOBEK AND HAROERIS
AT KOM OMBO.
In this sandstone bas-relief, a male body with
stiff hands and arms advances as if in a
procession. His royal pleated kilt hugs the
musculature of his thigh, and the front panel
is decorated simply with a frieze of uraei. The
knees are rather awkward. The work dates from the time Egyptian art had begun
its decline, prompted by the arrival of different invaders. Greco-Roman Period.

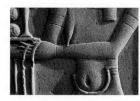

PAGE 55: NILE GOD.
TEMPLE OF SOBEK AND HAROERIS
AT KOM OMBO.
The Nile god, bearer of offerings, holds a
platter with loaves of bread and a vase. His
sadly distended teat does not evoke abundance,
and his plump stomach, emphasized by the roll
of fat that covers his loincloth, are indications of
a life gone by. He wears undecorated armlets on his wrists and upper arms. Sandstone
relief (see page 11). Greco-Roman Period.

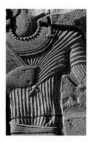

PAGE 56: ROYAL TORSO.
TEMPLE OF SOBEK AND HAROERIS AT KOM OMBO.
Though it may lack the charm of work from preceding eras,
this sandstone bas-relief still shows the sculptor's great
mastery for capturing the light to the piece's best advantage.
The king, who is recognizable by his khepresh. He wears a
pleated short-sleeved shirt that is a bit too small, and in his
right hand he holds two knotted sections of a matching
stole. Around his neck is a strand of beads resting on a
simply rough-hewn wesekh collar. Greco-Roman Period.

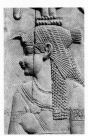

PAGE 57: MOTHER GODDESS.
TEMPLE OF SOBEK AND HAROERIS AT KOM OMBO.
This figure wears the skin of a vulture, the attributes of a mother goddess. The divinity's forehead and wig are covered by the head and the wings of the carrion eater, and the ensemble is surmounted by the *modius*, a kind of small crown formed of *uraei*. The goddess wears a tunic with straps that leave her breasts exposed. Her fleshy cheeks, chubby arms, and generous stomach allow us to date this sandstone relief to a late era. The armlets that adorn her arms are finely engraved, but the decoration of the necklace is unfinished. Greco-Roman Period.

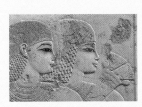

PAGE 58: KHESHY AND FRIEND;
DETAIL OF A FUNERAL FEAST.
TOMB NUMBER 55. NECROPOLIS OF SHEIKH ABD EL-GOURNAH. WESTERN THEBES.
The tomb of the governor and vizier Ramose is one of the largest and most beautiful carved in the limestone hills of Gournah. Here we admire the heads of two young people, Kheshy and his friend, with their delicately drawn faces and finely detailed wigs. It seems likely that the artist could not resolve to conceal his work with color as was the custom, preferring simply to use a stroke of black to outline the eye and to draw a brow. The artist here achieved the perfection of his art. Eighteenth Dynasty.

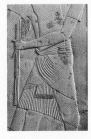

PAGE 59: PAPYRUS BEARER.
TOMB NUMBER 55. NECROPOLIS OF SHEIKH ABD EL-GOURNAH. WESTERN THEBES.
The elegance of the stride and the realism of the draped kilt, which follows the curves of the body as though the fabric were transparent, testify to the artist's superiority. The carefully modeled hand delicately holds the papyrus stalks. Although this tomb has been subject to degradations, the conserved vestiges are still admirable. Eighteenth Dynasty.

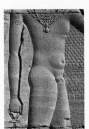

PAGE 60: THE INFANT GOD.
ROMAN *MAMMISI* (BIRTH CHAPEL) OF THE TEMPLE OF HATHOR AT DENDERA.
Egyptian art fell into decline in the Roman era. The modeling of this image of the child god typifies the changes. The slightly rounded forms we see here were unusual in earlier periods; however, the body shape is still relatively slender, and the depiction of the necklaces, armlets, and bracelets remains quite pleasing to the eyes (see page 61). Greco-Roman Period.

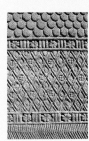

PAGE 61: THE TUNIC OF THE GOD IHY.
ROMAN *MAMMISI* OF THE TEMPLE OF HATHOR AT DENDERA.
The young god Ihy wears a woven or embroidered kind of long, great cape that reaches the ground. Various motifs extend from top to bottom: an arrangement of small feathers, a ribbon with an alternating design of a flower and three stripes, a large band of fabric in a diamond pattern edged with a second floral ribbon, and a chevron panel. The graphic composition of the whole reflects the artist's great skill (see page 60). Greco-Roman Period.

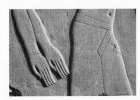

PAGE 62: MALE FIGURES.
OPEN-AIR MUSEUM. TEMPLE OF AMON RA AT KARNAK. EASTERN THEBES.
We are faced with a piece of an archaeological puzzle. Isolated from its context, the limestone block presents a detail of male figures respectfully participating in a royal or civil ceremony.

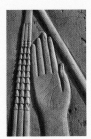

PAGE 63: HAND OF AN ITHYPHALLIC AMON RA.
OPEN-AIR MUSEUM. TEMPLE OF AMON RA AT KARNAK. EASTERN THEBES.
Detail of a limestone relief. Above the hand of the god Amon Ra rests a *nekhekh*, one of the insignia of power for gods and pharaohs. The design's simplicity underscores its beauty. Twelfth Dynasty.

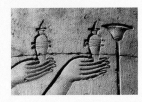

PAGE 64: OFFERING OF MILK.
TEMPLE OF SOBEK AND HAROERIS AT KOM OMBO.
Two hands hold pots of milk, which they present as an offering to a female divinity. All we see of her is her scepter, formed as an umbel-topped papyrus stalk. Relief carved in sandstone. Greco-Roman Period.

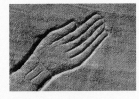

PAGE 65: GESTURE OF SALUTATION.
TEMPLE OF THE NUBIAN GOD MANDULIS AT KALABSHA, NUBIA.
Although it is a lovely gesture of welcome, this hand is depicted in a very rough style that reveals more about the state of provincial art. The great artists of the day preferred to work in capitals like Thebes and Memphis. Greco-Roman Period.

PAGE 66: RAMSES II.
TEMPLE OF LUXOR. EASTERN THEBES.
The arm of this granite colossus emits a most impressive power. The fist is clenched so hard that the forearm muscles bulge. While apparently simplifying volumes, the sculptor still respected anatomical realities (see pages 4, 20, and 28). Nineteenth Dynasty.

PAGE 67: KNEELING SETI II.
TEMPLE OF AMON RA AT KARNAK. EASTERN THEBES.
This red sandstone statue is found in the hypostyle hall. The lightly grained stone creates the impression that the figure has goose bumps, an understandable reaction for anyone kneeling before his god—even a pharaoh. The kilt pleats and the plaiting of the belt are clearly engraved, and the light sets off the straight line of his back and the oblique forward movement of the arm to advantage. The sandstone's natural appearance makes us forget that the majority of works were stuccoed and painted. The name of the king covers an even more ancient inscription. Nineteenth Dynasty.

PAGE 68: SUCKLING SCENE.
TEMPLE OF SOBEK AND HAROERIS AT KOM OMBO.
A series of hieroglyphics is presented in this detail. The sign for water, "_n_," which reads as _noub_, is placed on the collar. The egg and the sign "_t_," formed by a semicircular loaf of bread, determine the feminine. The ensemble signifies "that of gold," one of Hathor's attributes. The ideogram of a breastfeeding woman is found at right. Jean-François Champollion considered the writing system quite complex: "[…] A script that is simultaneously figurative, symbolic, and phonetic, in the same text, the same sentence…almost in the same word." Reign of Trajan.

PAGE 69: SUCKLING SCENE.
ROMAN _MAMMISI_ OF THE TEMPLE OF HATHOR AT DENDERA.
The scene of the goddess Hathor breastfeeding her son Ihy—who seems far too big to be an infant—appears on the exterior sandstone wall of the _pronaos_. In spite of the accumulation of corporal details and the elements of headwear, jewelry, and clothing, the artist succeeded in emphasizing the heart of the subject. By the rigor of the design's strong outlines, he showed with great clarity the interdependence of mother and child as well as the tenderness of the gesture. Greco-Roman Period.

THE ANIMAL WORLD

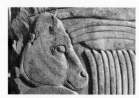

PAGES 70–71, 72: DETAIL OF A TABLE OF OFFERINGS.
OPEN-AIR MUSEUM. TEMPLE OF AMON RA AT KARNAK. EASTERN THEBES.
This limestone relief displays part of a table of offerings, which includes meats from a butcher's shop. At left is a calf's head propped on a large round loaf of bread; to the right are a plate of chops and ribs. The perfection of the bulges of the calf's cheek, eye, and nostril exemplify the care that Egyptian artists brought to their representation of animals. They made it an art.

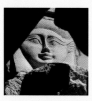

PAGE 74: HATHOR CAPITAL.
COLONNADE OF THE _MAMMISI_ AT THE TEMPLE OF ISIS AT PHILAE.
The term "Hathor capital" denotes the capitals with their distinct carving that topped the columns of temples dedicated to the goddess. Sculpted in her image, they consisted of such characteristic elements as a slightly flattened but smiling face and cow's ears jutting out from a large wig. This type of capital design later spread to other temples dedicated to female divinities and queens. Sandstone (see page 75). Greco-Roman Period.

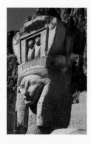

PAGE 75: SISTRUM COLUMN.
TEMPLE OF HATSHEPSUT AT DAYR AL-BAHRI. WESTERN THEBES.
The sistrum column is the prototype of the Hathor capital. Here, the figure characterized as Hathor wears a sort of grand crown over her wig. The crown is decorated with _uraei_ whose shape recalls the sistrum, a percussive musical instrument. The goddess loved its sound, for it reminded her of the wind rustling through the papyrus thickets of the marshes where she lived (see page 74). Eighteenth Dynasty.

PAGE 76: SEKHMET.
TEMPLE OF AMON RA AT KARNAK. EASTERN THEBES.
This diorite statue of a lioness-headed woman wears the solar disk on her head. She stands in the temple of Ptah, located within the temple of Amon Ra. A little larger than life-size, the whole work stands out from the shadows only when sunlight slips in through the slits in the roof. Then, from the near-permanent obscurity, the muzzle of the lioness emerges, and little by little her body takes shape. This narrow opening also allowed the priests to illuminate the statue of the goddess at any time by means of a polished metal mirror, which allowed them to capture and direct the external light (see pages 23, 26, and 77). Eighteenth Dynasty.

PAGE 77: SEKHMET.
OPEN-AIR MUSEUM. TEMPLE OF AMON RA AT KARNAK. EASTERN THEBES.
Penetrating in its realism, this head of a lioness exhibits all the characteristic traits of the animal. The carefully rendered ears, erect and attentive, show the ferocity of this daughter of Ra, ready to defend her father, the sun god. The tresses falling from the tripartite wig and the generous bosom highlight her femininity. A significant quantity of similar statues discovered in the temple of Mut can be found in great museums and collections throughout the world (see pages 23, 26, and 76). Eighteenth Dynasty.

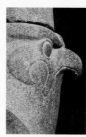

PAGE 78: HORUS.
TEMPLE OF HORUS AT EDFU. UPPER EGYPT.
This falcon's head belongs to one of the two colossi that keep watch from the front of the temple at Edfu. The head reveals the raptor side of the god Horus. Egyptians sculptors were remarkable animal artists. They captured those essential elements that distinguish the falcon perfectly: the short hooked beak, the round eye firmly fixed under the pronounced arch of the eyebrow, and, on the cheek, the movement of highly stylized feathers (see page 79). Greco-Roman Period.

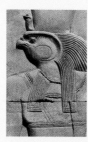

PAGE 79: HAROERIS.
TEMPLE OF SOBEK AND HAROERIS AT KOM OMBO.
This beautiful profile, engraved in sandstone, is of a Haroeris falcon, one of the two gods of the temple of Kom Ombo. The head is particularly well defined and is highlighted even more, as the artist left the details of the necklace and the crown uncompleted. The pronounced rounded grooves of the wig further underline the impression of movement. Haroeris is considered "the elder Horus" (see page 78). Greco-Roman Period.

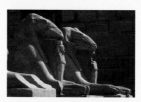

PAGE 80: _DROMOS_.
TEMPLE OF AMON RA AT KARNAK. EASTERN THEBES.
Originally 170 feet (52 meters) long, this _dromos_ is situated in front of the first pylon of Karnak. Sandstone sphinxes, the true "guardians of the entry to the temple," form a processional pathway leading to the landing jetty. Each sphinx represents the god Amon in his form as a ram and, protected between chin and paws, each holds an Osiride statue. All the statuettes were in the name of Ramses II, but Pinedjem I also imposed his own cartouche later (see page 81). Nineteenth to Twenty-first Dynasties.

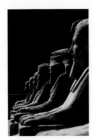

PAGE 81: *DROMOS.*
TEMPLE OF LUXOR. EASTERN THEBES.
This *dromos* linking the two temples of Amon Ra, those of Karnak and Luxor, measures over 18 miles long (30 kilometers). Carved out of sandstone, these late-period sphinxes bear human heads patterned in the image of the reigning king (see page 80). Reign of Nectanebo. Late Period.

PAGE 82: STANDING *URAEUS.*
RELIEF ON THE TEMPLE OF SOBEK AND HAROERIS AT KOM OMBO.
This cobra figure is a detail of an engraving on one of the walls of the temple at Kom Ombo. In its entirety, the scene represents two standing cobras. They protect the royal name, which is inscribed in the cartouche—a small part of the cartouche's contour is visible on the left. The reptile's flattened head seems poised to attack, with pouches of venom puffing up its throat. On its forehead it wears a crown consisting of two bovid horns encircling a disk flanked by two tall plumes, a sign that we stand here facing a female deity. Greco-Roman Period.

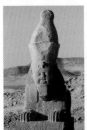

PAGE 83: SPHINX.
TEMPLE OF RAMSES II AT WADI EL-SEBOUA. NUBIA.
Carved in a provincial style, this sandstone sphinx wears the double royal crown, or *pschent,* on its human head. The figure is part of the *dromos* of a temple dedicated to the divine triad formed of Ra, Ra Horakhty, and Ramses II. The name of Wadi el-Seboua means the "valley of the lions" (see pages 80 and 81). Nineteenth Dynasty.

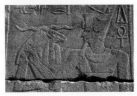

PAGE 84: THE GOD KHNUM AND A KING.
TEMPLE OF SATET AT ELEPHANTINE ISLAND. ASWAN.
Khnum, the ram god, is the deity of the First Cataract. It was he who fashioned man out of the clay of the Nile. Here Khnum wears a mane-wig, twisted horns, and a short beard, and he welcomes a king adorned with the red crown of Lower Egypt. Even though the panel is badly damaged, some traces of red pigment are still perceptible, notably on the bodies of the god and the monarch. This relief comes from the recently reconstructed chapel of Hatshepsut and Thutmose III. Eighteenth Dynasty.

PAGE 85: HUNT OF THE WILD BULLS.
TEMPLE OF RAMSES III AT MADINAT HABU. WESTERN THEBES.
On the south wall of the first pylon, this realistic scene shows a bull in its death throes, while another takes refuge in the reeds of a fish-filled swamp. The front legs of the harnessed horses of the royal chariot are visible in the top corner. This very vivid representation contrasts sharply with more conventional scenes. Twentieth Dynasty.

PAGES 86–87: LEAPING LION.
TEMPLE OF SOBEK AND HAROERIS AT KOM OMBO.
This traditional scene shows the king, accompanied by his pet lion, striking down his enemies. It comes from the northeast wall of the temple, and this detail allows us to appreciate the mythical importance and the violent realism of animal representations in Egyptian sculpture. The lion leaps as if alive, his muscles stretched to the extreme, his claws long and menacing. He seems to hurl his anger at the numerous kneeling vanquished foes. We see only their elbows, backs, and flexed feet—a contrast to the elegance of the king, shod in a buckled sandal. Sandstone relief. Greco-Roman Period.

PAGE 88: BLACK CALF.
OPEN-AIR MUSEUM. TEMPLE OF AMON RA AT KARNAK. EASTERN THEBES.
His leg hobbled by a rope, this young calf is a detail from the magnificent reliefs of the alabaster chapel of Amenhotep I. On the right appears the hieroglyphic sign *kemet,* which means "black." The head is perfectly rendered, and the hollows tracing the animal's contour cast a delicate shadow. The calf is part of the scene in which the king holds the reins of four calves—black, red, white, and pied—in the gesture of an offering. Eighteenth Dynasty.

PAGE 89: PLANTS AND BIRDS.
AKH MENU. TEMPLE OF AMON RA AT KARNAK. EASTERN THEBES.
The *Akh menu* of Thutmose III contains a "cabinet of curiosities" in which examples of local flora and fauna, combined with those brought back by a royal expedition to Syria and Arabia, were engraved on the sandstone walls. The scene depicts an opening up to a world that the king wanted to display in this holy place. At the bottom of the detail we recognize the willow *Salix subserrata,* while above, from right to left, are the blue lotus flower, two passerine birds, and a much smaller, unidentified bird. A falcon hovers at the summit. Eighteenth Dynasty.

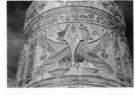

PAGE 90: COLUMN.
TEMPLE OF SOBEK AND HAROERIS AT KOM OMBO.
On the column's central drum are the two titular vulture goddesses of Egypt. Back to back and with open wings, they wear their respective crowns: on the figure on the left, the red crown of Lower Egypt; to the right, the white crown of Upper Egypt. Two *nekhekh* whips are engraved near their napes. Between their wings, they carry composite scepters formed of a stylized feather whose quill bisects the rounded *shenu* sign. The vultures perch on *neb* baskets. This sandstone column has partially conserved its original coloring. Greco-Roman Period.

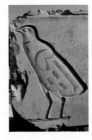

PAGE 91: QUAIL CHICK.
OPEN-AIR MUSEUM. TEMPLE OF AMON RA AT KARNAK. EASTERN THEBES.
Engraved in limestone, this quail chick corresponds to the letter "<u>w</u>" in the hieroglyphic alphabet. In this artist's lovely study, this baby bird's small feathers indicate that it cannot yet fly. It carries the traces of its yellow down, and its legs are painted a dark color. Twelfth Dynasty.

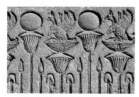

PAGE 92: *REKHYT.*
MAMMISI OF THE TEMPLE OF HATHOR
AT DENDERA.
With their great wings raised behind them,
these crested birds, symbolic of the king's
subjects, are carved on a sandstone foundation.
The lapwings, their long legs folded beneath
them, are poised on *neb* baskets—which
signify "everything." In turn, they themselves are balanced on papyrus umbels and
accompanied by lotus buds and leaves. The tallest papyrus stalks are topped by
solar disks. In front of these, the birds raise one wing and rest the other on their
bellies in a salute that shows respect and adoration. The rebuslike image reads: "All
the *rekhyt* worship the sun" (see page 95). Greco-Roman Period.

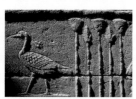

PAGE 93: GOOSE WALKING NEAR
A THICKET OF PAPYRUS.
MAMMISI OF THE TEMPLE OF PHILAE.
On this sandstone relief, three papyri and two
lotus evoke a marsh. A goose walks placidly by.
These simple elements conjure up a rural scene,
but no image that adorns an Egyptian temple is
meant to be merely decorative. This goose is no
innocent figure. A principal actor in the divine world of the Egyptians, this bird is
also one of the animal figurations of the great god Amon. Greco-Roman Period.

PAGE 94: HIEROGLYPHICS.
OPEN-AIR MUSEUM. TEMPLE OF AMON RA AT KARNAK.
EASTERN THEBES.
From top to bottom, we read like so: the lower part of the
heart, "*ib,*" seen from the front; the backbone and its spinal
cord, "*aoui*"; and the sign "*k,*" denoted by a hand basket. The
sign "*m*" is represented by an owl, covered in sleek plumage.
The frontal position of the bird of prey's head is an excep-
tional treatment of subsidiary characters, whether human or
animal, usually depicted in profile on reliefs and paintings.
The sculptor effortlessly disregarded the strict artistic
conventions of the times, for he knew, as a careful observer of nature, that it was the
only way to show the owl's flat yet round face and its fixed eyes. Twelfth Dynasty.

PAGE 95: *REKHYT.*
BARK-SHRINE OF HATSHEPSUT. TEMPLE OF
AMON RA AT KARNAK. EASTERN THEBES.
This relief from the silicified sandstone Bark-
Shrine of Hatshepsut is a little more explicit
than the one at Kom Ombo (see page 92).
These lapwings, symbolizing the hoi polloi,
raise their wings in a gesture of adoration, but
this time the meaning is confirmed by the presence of the *dua* (or dawn star),
signifying worship. Eighteenth Dynasty.

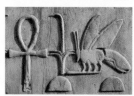

PAGE 96: HIEROGLYPHICS.
OPEN-AIR MUSEUM. TEMPLE OF AMON RA
AT KARNAK. EASTERN THEBES.
The three hieroglyphics pictured here are
frequently composed together. From left to
right appear the life sign *ankh*, the rush plant
sign *nesut*, corresponding to Lower Egypt,
and the bee sign *bity*, corresponding to Upper
Egypt. The latter two signs each dominate the letter "*t.*" Represented by a loaf of
bread, this indicates the female. This ensemble often accompanies the royal titular.
Limestone relief. Twelfth Dynasty.

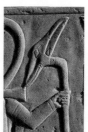

PAGE 97: HIEROGLYPHICS.
TEMPLE OF SOBEK AND HAROERIES AT KOM OMBO.
Taken from a sandstone relief in the entry of the *pronaos*,
this detail of a hieroglyphic ensemble shows the life sign
ankh endowed with arms. In his hand, the personified *ankh*
holds a *was* scepter, whose top is decorated with the head of
an animal with small eyes, beveled ears, and an elongated
snout. A number of identifications are possible: donkey,
anteater, greyhound, or okapi. All of these are considered
auxiliary characters attributed to Seth, the god of evil. The
question then arises as to why the god of evil plays the role
of a protector here. Greco-Roman Period.

PAGE 98: DETAIL OF A DOOR LINTEL.
TEMPLE OF THE NUBIAN GOD MANDULIS
AT KALABSHA. NUBIA.
Temple entryways are always protected. On
this sandstone door lintel—of which we see
only one half—the vulture goddess Nekhbet
guards the passage with her almost completely
unfurled wings. Both the small and large
feathers are clearly delineated. There is no need to see the head of the bird, for the
wings are sufficiently large. This motif, with its same protective significance, is often
found on the clothing of kings, queens, gods, and goddesses. Reign of Augustus.

PAGE 99: SCREENWALL.
TEMPLE OF SOBEK AND HAROERIS
AT KOM OMBO.
The *uraei* frieze offers a further element of
protection. The heads crowned with the solar
disk, the erect bodies of the goddesses, and the
cobras' venomous strength form an insur-
mountable hurdle. This example comes from
the top of the screenwall of medium height that connected columns of the *pronaos*.
It is a characteristic portico of temples constructed in the Late Period. Traces of the
original color are still visible. Greco-Roman Period.

THE PLANT WORLD

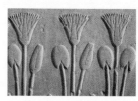

PAGES 100–101, 102: LOTUS FRIEZE.
OPEN-AIR MUSEUM. TEMPLE OF AMON RA
AT KARNAK. EASTERN THEBES.
This charming floral decoration appears on
one of the limestone blocks in the open-air
museum at Karnak. Three rather realistic
Nymphaea caerulae (blue lotus) emerge from
somewhat sketchily treated buds and leaves.
Another kind of umbel appears at left, that of the white lotus, *Nymphaea lotus*,
which appears more often in later eras. More than just a simple decorative element,
the blossoming of the blue lotus's corolla symbolizes the sun at dawn.

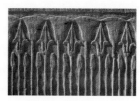

PAGE 104: ALTERNATING LOTUS AND LILIES (?).
TEMPLE OF SOBEK AND HAROERIS
AT KOM OMBO.
Evoking the primordial marsh in which all life
had its beginning, these motifs are found at the
base of some walls. Flowers were so stylized
in the Late Period that it was often hard to
differentiate them. The stalks with the great
umbels may be papyrus, but the absence of color makes them difficult to identify.
Greco-Roman Period.

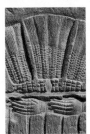

PAGE 105: OFFERING OF EARS OF WHEAT.
TEMPLE OF SOBEK AND HAROERIS AT KOM OMBO.
Male and female, bearers of offerings often decorate the
exterior walls of temples. They generally represent the Nile
gods and sometimes types of rural divinities. This detail
from a sandstone relief shows ears of grain-rich wheat that
denote the ancient Egyptian harvest season, that is to say
the summer, or *shemu*. The hands, belonging to a young
female who is out of view on the right, are in an unnatural
position; it is not a mistake by the artist but rather a gestural
convention. Greco-Roman Period.

PAGE 106: BASE OF A BUNDLE COLUMN.
TEMPLE OF LUXOR. EASTERN THEBES.
This image shows the stylized base of the bundle columns
that are typical of the New Kingdom. These examples are in
the temple of Luxor—constructed at the time of Hatshepsut—
in front of the repository chapel of the Theban triad in the
first court. The grooves correspond to the small leaves
found on the lower part of the papyrus stalk. Eighteenth
Dynasty.

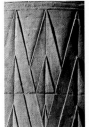

PAGE 107: COLUMN BASE.
TEMPLE OF HORUS AT EDFU.
Egyptian art of the Late Period adapted itself to the palate
of the invaders, and decorative motifs in particular were
treated either by simplification (see page 108) or by
flamboyance (see page 114). At the base of this sandstone
column from the *pronaos* of the temple of Horus, we see
how the extremely sketchy approach transformed the small
leaves of the papyrus plant into a purely graphic design of
chevrons. Greco-Roman Period.

PAGE 108: COLUMN BASE.
TEMPLE OF SOBEK AND HAROERIS AT KOM OMBO.
The *pronaos* of the temple of Kom Ombo contains column
bases carved with geometrically intertwined papyrus
leaflets. At certain times of the day, the light animates this
pattern of diagonals. Greco-Roman Period.

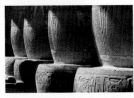

PAGE 109: BASE OF COLUMNS FROM
RAMSES III.
TEMPLE OF RAMSES III AT MADINAH HABU.
WESTERN THEBES.
This is a view of the second court of the
"millions of years" temple of Ramses III. Here
we see the volume of columns beginning to
grow, compared to the more slender supports
of preceding eras. This time the decoration is exuberant, but the ensemble
maintains a lovely coherence. The colossal appearance of the columns gives visitors
the impression of being transported to a world of a scale that far exceeds the
human. Twentieth Dynasty.

PAGE 110: COLONNADE OF THUTMOSE III.
Akh menu. TEMPLE OF AMON RA AT KARNAK.
EASTERN THEBES.
The courtyard of columns, called the "festival hall" of the
Akh menu, contains a rare style of pillar design. The red-
painted round shafts evoke the wooden poles that were
used in earlier times to support tents. As part of a complex
ensemble constructed for Thutmose III, the sanctuary room
allowed the king to pass from the dark underworld to the solar
realm and thus to rebirth. It remains a unique monument in the
history of Egyptian temple architecture. Eighteenth Dynasty.

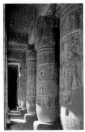

PAGE 111: COLONNADE OF RAMSES III.
TEMPLE OF RAMSES III AT MADINAH HABU.
WESTERN THEBES.
Here in the second court of the temple of Ramses III at
Madinah Habu, the sun plays with the bases of the columns.
Its radiance diffuses a soft luminescence that extends up to
the sky-blue ceiling, allowing us to see the ensemble of rich
decorations with their partially preserved colors (see page
109). Twentieth Dynasty.

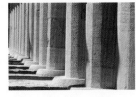

PAGE 112: COLONNADE OF HATSHEPSUT.
TEMPLE OF HATSHEPSUT AT DAYR AL-BAHRI.
WESTERN THEBES.
This "millions of years" temple, created by the
great architect Senenmut for the female pharaoh
Hatshepsut, was designated the *Djeserdjeseru*,
"the most splendid of the splendid." The
sixteen-sided limestone pillars shown here are
found in the third terrace. They are the prototypes of future pre-Doric columns that
were common in the golden age of Greek architecture in the fifth century BC.
Eighteenth Dynasty.

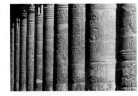

PAGE 113: COLONNADE.
TEMPLE OF ISIS AT PHILAE.
Constructed on the island of Philae at the
southern tip of Egyptian territory, this temple
was the bastion of the cult of Isis until AD 552.
A series of thirty-two columns stretching from
the left of the landing jetty led up to the
sanctuary. All the coloration of this sacred
group has been lost due to the repeated flooding of the Nile waters, which covers
them almost completely. In order to save the structures, UNESCO undertook from
1972 to 1980 to move them from to the island of Agilkia, a smaller location but one
that is out of reach of the rising waters. Greco-Roman Period.

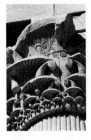

PAGE 114: CAPITAL.
TEMPLE OF KALABSHA. NUBIA.
Composite capitals, formed of an amalgam of stylized
plants, have been carved since the Ptolemaic era. In this
example, lotus and papyrus umbels bend in every direction
and expand as they rise and reach the top. The interstices
are filled with the delicate arabesques of vine branches.
Greco-Roman Period.

PAGE 115: CAPITAL.
TEMPLE OF SOBEK AND HAROERIS AT KOM OMBO.
Among the variety of capitals found in the interior of the temple *pronaos*, we find this example of a palmate motif whose prototype stretches back to the Old Kingdom. By using a slender design and beautiful curves, the sculptor responded to the later eras' need for stylization (see pages 114, 118, 119, and 120). Greco-Roman Period.

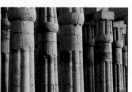

PAGES 116–17: COLONNADE OF AMENHOTEP III.
TEMPLE OF AMON RA AT LUXOR.
EASTERN THEBES.
Dating from the time of Amenhotep III, this court sits in the heart of the temple of Amon Ra at Luxor. It is surrounded by papyriform bundle columns. At the top of each column, a carved cord holds the buds and flowers in its five twists. The stalks bulge as if swollen by the waters of the Nile, evoking the primordial marsh. Eighteenth Dynasty.

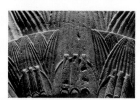

PAGE 118: CAPITAL.
COLONNADE OF THE *PRONAOS* TO THE TEMPLE OF ISIS AT PHILAE.
The large lotus petals with their delicate ribs are easy to distinguish on this base of a sandstone composite capital. The sketchy treatment of the other plants makes them too difficult to identify. Greco-Roman Period.

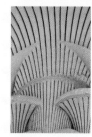

PAGE 119: CAPITAL.
TEMPLE OF QERTASSI. NUBIA.
This capital presents a bouquet of extremely stylized papyrus flowers. At its summit, the column blossoms into a skillful interweaving of plants and forms an umbel. Greco-Roman Period.

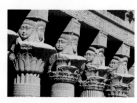

PAGE 120: CAPITAL.
COLONNADE OF THE *MAMMISI* OF THE TEMPLE OF ISIS AT PHILAE.
The temple of the goddess Isis at Philae is home to these capitals, carved with the features of the goddess Hathor (see pages 74 and 75). Carved on top of a composite capital, her smiling face seems to emerge from a flower bouquet, creating a charming combination of human and plant life. Greco-Roman Period.

PAGE 121: *PRONAOS* CEILING.
TEMPLE OF KHNUM AT ESNA.
The temple at Esna is dedicated to Khnum, the ram-headed god of the First Cataract. Typical of Late Period sanctuaries, this *pronaos* was built with twenty-four columns. The composite capitals that decorate them frame a ceiling showcasing the gifts of astronomy. This design demonstrates the importance to priests of the study of the heavens and the movement of the stars, which was used to determine the dates of annual liturgical celebrations, foretell the floods of the Nile, and establish propitious times for important ventures such as construction. Greco-Roman Period.

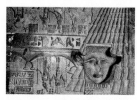

PAGES 122–23: ASTRONOMICAL CEILING.
TEMPLE OF HATHOR AT DENDERA.
In the temple of Hathor at Dendera, the coffered 49-foot (15-meter) ceiling in the hypostyle hall is adorned with painted ornamentation. The head of Hathor with its cow ears (see pages 74, 75, and 120) appears in the coffer on the left. The goddess's radiant face receives the rays of the sun god Ra, destined not only to protect but also to preserve her temple. The façade, drawn in elevation style, is visible under Hathor's chin. Greco-Roman Period.

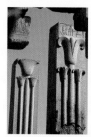

PAGE 124: HERALDIC PILLARS.
TEMPLE OF AMON RA AT KARNAK. EASTERN THEBES.
These two square pillars reach 25 feet (7.5 meters) in height. Carved in granite, they were enhanced by paint and symbolically placed in the temple on a north-south axis. Sculpted in high relief, they are adorned with the two heraldic plants of Egypt. The pillar in the foreground is decorated with a lily, often mistaken for a lotus, symbol of Upper Egypt. The other bears the papyrus, symbol of Lower Egypt. Together they formed a veritable monument to the glory of Thutmose III. Eighteenth Dynasty.

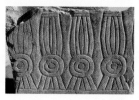

PAGE 125: *KHEKERU* FRIEZE.
OPEN-AIR MUSEUM. TEMPLE OF AMON RA AT KARNAK. EASTERN THEBES.
The *khekeru* stretches back to early history, when people constructed their homes with palms or woven reeds. The huts disappeared over time, but the *khekeru*, in the form of reliefs or paintings, continued to protect the tops of walls, temples, and tombs down through later eras. The design is visible here on an isolated block of multicolored limestone.

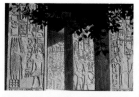

PAGE 126: BARK-SHRINE OF SESOSTRIS I.
TEMPLE OF AMON RA AT KARNAK.
EASTERN THEBES.
The Bark-Shrine of Sesostris I is covered with representations of the king and the god Amon. The delicate precision of the limestone reliefs recalls a silversmith's artistry. This small building served as a sacred storage place for the bark containing the statue of the god. It was an important stop along the processional way and a site for festivals. Twelfth Dynasty.

PAGE 127: SETI I UNDER THE *ISHED* TREE.
TEMPLE OF AMON RA AT KARNAK. EASTERN THEBES.
On the sandstone wall of the great hypostyle hall, King Seti I kneels under the sacred *ished* tree that is represented in a conventional style behind him. Dressed in a short pleated kilt and wearing the *khepresh*, he holds the *heqa* scepter in one hand and a fruit inscribed with his name in the other. Behind him is the hand of the god Thoth, patron of scribes, holding a shell in the guise of an inkwell. With its sinuous naturalistic branches, foliage, and fruits, the *ished* tree forms a remarkable arboreal backdrop to a scene treated with great sensitivity. Nineteenth Dynasty.

CHRONOLOGY

OLD KINGDOM: 2575–2134 BC

MIDDLE KINGDOM: 2040–1640 BC
 Twelfth Dynasty: 1991–1783 BC
 Sesostris I: 1971–1926 BC

 Thirteenth Dynasty: 1783–1690 BC

NEW KINGDOM: 1550–1070 BC
 Eighteenth Dynasty: 1550–1307 BC
 Amenhotep I: 1525–1504 BC
 Thutmose III: 1479–1425 BC
 Hatshepsut: 1473–1458 BC
 Amenhotep II: 1427–1401 BC
 Thutmose IV: 1401–1391 BC
 Amenhotep III: 1391–1353 BC
 Tutankhamen: 1333–1335 BC
 Horemheb: 1319–1307 BC

 Nineteenth Dynasty: 1307–1196 BC
 Seti I: 1306–1290 BC
 Ramses II: 1290–1224 BC
 Seti II: 1214–1204 BC

 Twentieth Dynasty: 1196–1070 BC
 Ramses III: 1194–1163 BC
 Ramses IV: 1151–1143 BC

THIRD INTERMEDIARY PERIOD: 1070–712 BC
 Pinedjem I: 1070–1032 BC

LATE PERIOD: 712–332 BC
 Taharqa: 690–664 BC

GRECO-ROMAN PERIOD: 332 BC–AD 395

REIGN OF AUGUSTUS: 27 BC–AD 14

REIGN OF TRAJAN: AD 98–117

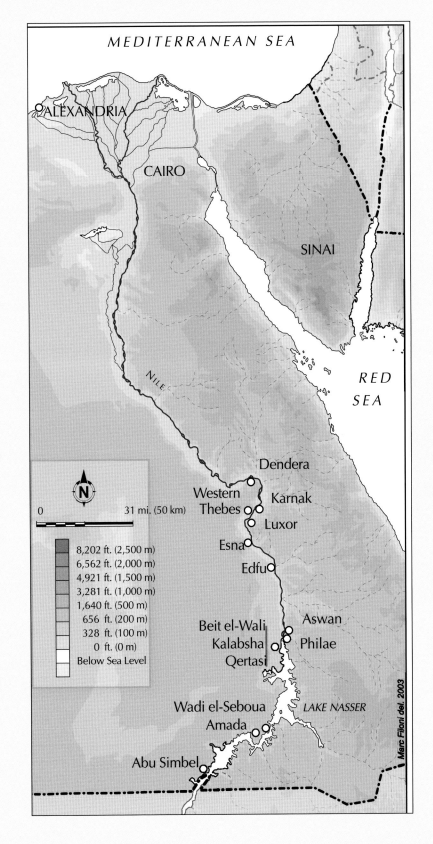

Glossary

Akh menu: "The diamond of monuments," a reference to the temple of Thutmosis III, built in the compound of the temple of Amon Ra at Karnak and situated after the court of the Middle Kingdom.

Bundle Column: Stone column carved in the shape of a bundle of papyrus or lotus stalks.

Devanteau: Frontal projection of the kilt worn by Egyptian men.

Dromos: Protective path to the temples, formed by a row of sphinxes with human or animal heads.

Hathor Capital: A capital carved with the distinctive flattened face and cow's ears of the goddess Hathor.

Heqa: Scepter in the form of a shepherd's crook.

Ished: The Balanites aegyptiaca tree, also known as the desert date.

Kemet: Literally, "black." Used to signify the land of Egypt, as well as the color black.

Khepresh: Helmetlike blue crown frequently worn for battle and by the kings of the New Kingdom.

Mammisi: "Birth chapel." Small buildings located in Ptolemaic temple compounds used to celebrate the births of gods and kings.

Modius: Small diadem of *uraei* worn by goddesses and queens.

Mummiform: In the shape of a mummy.

Nekhekh: Scepter in the shape of a flail.

Nemes: Blue-and-yellow striped fabric headdress worn by the pharaohs.

Nomarch: The governor of a province or district (*nome*).

Osiride: In the form of Osiris.

Pschent: The double crown combining the red crown of Lower Egypt over the white crown of Upper Egypt.

Royal Title: The ensemble of epithets accorded to a pharaoh.

Sema tawy: The union of Upper and Lower Egypts as symbolized by their plants: the lily (or lotus) and the papyrus.

Shebyu: Necklace formed of gold rings, usually offered by the king as a reward.

Shenu: Cord knotted and joined in a circle, signifying permanence.

Speos: Cut rock temple or sanctuary in cliff or mountain.

Tripartite Wig: Wig formed of three sections or tresses, worn by deities.

Uraeus, uraei: An erect cobra or snake head. Used to ward off evil, it also represents a female divinity.

Wesekh: Wide, flexible collar made of concentric rows of beads.

Selected Bibliography

Arnold, Dorothea, et al. *Egyptian Art in the Age of the Pyramids.* New York: Metropolitan Museum of Art/Harry N. Abrams, Inc., 1999.

Aufrère, Sydney H. *Encyclopédie religieuse de l'univers végétal*, vols. 1 and 2. Montpellier: Orientalia Monspeliensia X, Université Paul Valery: 1999 and 2001.

Baines, John, and Jaromik Malek. *Cultural Atlas of Ancient Egypt.* New York: Checkmark Books, 2000.

Barguet, Paul. "Le temple d'Amon-Ré à Karnak" in *Recherche d'archéologie, de philologie et d'histoire*, vol. 21. Cairo, 1962.

Daumas, François. *La civilisation de l'Égypte pharaonique*, Les grandes civilisations series. Paris: Éditions Arthaud, 1965.

De Putter, Thierry, and Christina Karlshausen. *Les pierres utilisées dans la sculpture et l'architecture de l'Égypte pharaonique.* Brussels: Connaissance de l'Égypte ancienne, 1992.

Hawass, Zahi A. *Silent Images: Women in Pharaonic Egypt.* New York: Harry N. Abrams, Inc., 2000.

———. *Valley of the Golden Mummies.* New York: Harry N. Abrams, Inc., 2000.

Houlihan, Patrick F. *The Birds of Ancient Egypt.* Warminster: Aris & Philips, 1987.

Porter, Bertha, Rosalind L.B. Moss, et al. *Theban Temples*, vol. 2 of *Topographical Bibliography of Ancient Egyptian Hieroglyphic Texts, Reliefs, and Painting*, 2d ed. Oakville: David Brown Book Co., 2000.

Posener, Georges, Serge Sauneron, et al. *Dictionnaire de la civilisation égyptienne.* Paris: Éditions Hazan, 1959.

Robins, Gay. *The Art of Ancient Egypt.* Cambridge: Harvard University Press, 1997.

Rossi, Guido Alberto, et al. *Egypt: Gift of the Nile, An Aerial Portrait.* New York: Harry N. Abrams, Inc., 2000.

Schwaller de Lubicz, R.A., V. and G. de Miré, et al. *The Temples of Karnak: A Contribution to the Study of Pharaonic Thought.* Rochester: Inner Traditions International Ltd., 1999.

Tiraditti, Francesco, ed. *Egyptian Treasures: From the Egyptian Museum in Cairo.* New York: Harry N. Abrams, Inc., 1999.

Wildung, Dietrich. *Egypt: From Prehistory to the Romans.* Cologne: Taschen Verlag, 1997.

ASWAN: UNFINISHED GRANITE COLOSSUS FROM TIME OF THE PHARAOHS. *These quarries, still mined today, retain the marks of the ancient quarrymen.*

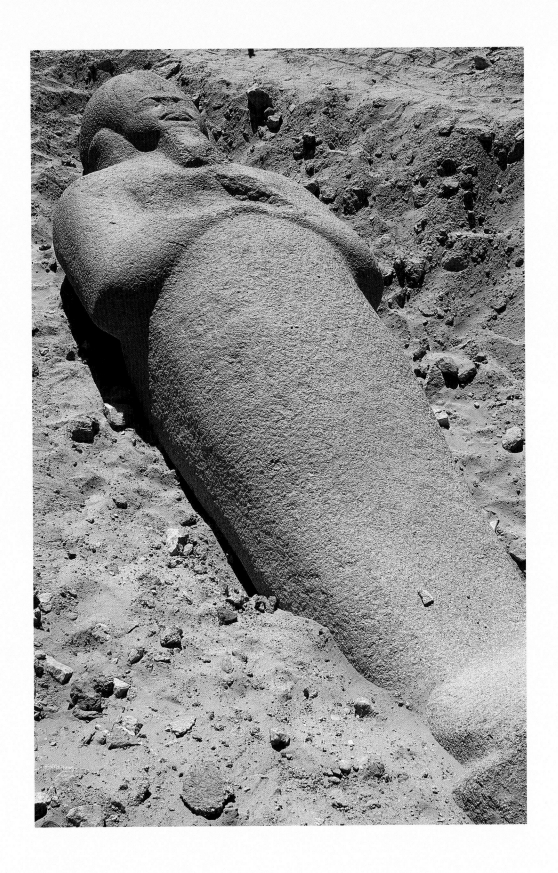

CONTENTS

ACKNOWLEDGMENTS

The photographer would like to thank Les Voyages de Pharaon (20, rue des Fossés-Saint-Bernard, 75005 Paris; Tel.: 011 33 1 43 29 36 36) for all their assistance and for the quality of their services. He would also like to thank Belle Époque Travel (M. S. Eugénie and M. S. Kasr Ibrim) and Naggar Travel for the opportunities afforded him regarding cruises on Lake Nasser and the Nile.

The author sends many heartfelt thanks to Hélène Bakhoum for her friendly and patient assistance.

Project Manager, English-language edition: Susan Richmond
Editor, English-language edition: Virginia Beck
Jacket design, English-language edition: Robert McKee
Design Coordinator, English-language edition: Tina Thompson and Robert McKee

Library of Congress Control Number: 2003109610
ISBN 0–8109–4843–5

Printed and bound in France
10 9 8 7 6 5 4 3 2 1

 Harry N. Abrams, Inc.
100 Fifth Avenue
New York, N.Y. 10011
www.abramsbooks.com

Abrams is a subsidiary of
 LA MARTINIÈRE
G R O U P E